We Are 'Nature' Defending Itself

"We need stories of victory! We need stories of transformative imagination and wild adventures that somehow succeed against all odds. Jay and Isabelle think about organising and activism like nobody else. They've given us more than an account—they've created a new myth that has the added benefit of being true."

Starhawk

VĀG
ABO
NDS

Radical pamphlets to fan the flames of discontent
at the intersection of research,
art and activism.

Series editor: Max Haiven

Also available

001
*Pandemonium: Proliferating Borders of Capital
and the Pandemic Swerve*
Angela Mitropoulos

002
*The Hologram: Feminist, Peer-to-Peer
Health for a Post-Pandemic Future*
Cassie Thornton

003

We Are 'Nature' Defending Itself

Entangling Art, Activism and Autonomous Zones

Isabelle Fremeaux and Jay Jordan

PLUTO PRESS

First published 2021 by Pluto Press
New Wing, Somerset House, Strand, London WC2R 1LA

www.plutobooks.com

Published in collaboration with the Journal of Aesthetics
& Protest

joaap.org

British Library Cataloguing in Publication Data
A catalogue record for this book is available from the
British Library

ISBN 978 0 7453 4587 1 Paperback
ISBN 978 0 7453 4591 8 PDF
ISBN 978 0 7453 4589 5 EPUB

This book is printed on paper suitable for recycling and
made from fully managed and sustained forest sources.
Logging, pulping and manufacturing processes are
expected to conform to the environmental standards of
the country of origin.

Typeset by Stanford DTP Services, Northampton,
England

Simultaneously printed in the United Kingdom and
United States of America

VĀG
ABO
NDS

Contents

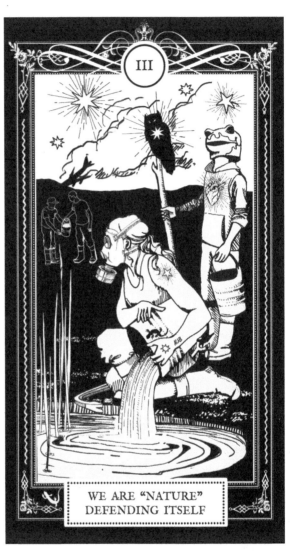

WE ARE "NATURE"
DEFENDING ITSELF

Artist: Amanda Priebe

VAG
ABO
NDS

Preface by Marc Herbst

The entangled and extended autonomous rebel community that comprises the zad, located near the village of Notre-Dame-des-Landes in Brittany, kicked the French state's ass.

They scared off the cops and their courts and ruined some dumb multinational's plans for stupid stuff. There was a time when the heart of this book would simply be a discussion of how the state was forced to come to terms with these rads so that instead of an airport, their squatted homes and farms were allowed to stay.

But, as the reader knows, large and actually meaningful insurrectionary movements are heterogenous beasts. And our authors, Isa and Jay of the Laboratory of Insurrectionary Imagination (LABOFII), would be the first to say that there are a million ways to tell its story. So, *We Are 'Nature' Defending Itself* is their story, an ecofeminist book showing how attention to ritual, art and actually existing relations are more than theoretical; the combination of these things is constitutive of their radical success. These things constitute an art that aims toward constructing other livable futures.

Magic happens, bitches.

The zad; a play on a French government acronym, meaning *a zone to defend.*

4,000 acres of wetland

The dumb idea: building an airport NO ONE NEEDS

Salamanders and tractors

A good idea: "to defend a territory, you need to inhabit it"

70 squats, over 300 rebel residents

6 years (pretty much) without the state

Cows and barricades

40,000 people occasionally appear to put a halt to the dumb plans

Cheese mongers, a sawmill, radio station, flour mill, and more

Teargas, concussion grenades, rubber bullets, and worse

Tanks and wounds

Songs and ritual

The airport will never be built

A Revenge against the commons and frogs

It is now May 2021, though a manuscript of this book had been delivered to me at the beginning of 2016. At that point it was a nearly complete blow-by-blow of the zad's struggle. The book was originally envisioned as a call to arms for the English-speaking world, to be published by the *Journal of Aesthetics & Protest*, which I co-edit. Eager to go to press, the book's deadline somehow nevertheless kept on being pushed back . . . because the people of the zad kept winning. It became apparent that we wouldn't be publishing

a call to arms for a battle yet to come, but rather something else, a reflection on victories.

Before they moved to the zad and became land defenders I had come to know the authors, Jay and Isa, as city creatures: high-achieving university-trained individuals who'd excelled in the critical and radical spaces carved from arts and academia. I initially read their critical attention to art in the early drafts of this book as a hold-over from their concerns at that time. As an editor with a long engagement with activist art and theory, I knew them as artivists whose creative activities impacted countless movements. As individuals and together as The Laboratory of Insurrectionary Imagination (LABOFII), they'd applied their skills on a variety of fronts; in the 1990s Jay had collaborated in founding Reclaim the Streets that made a wild party of disruptive protest; which besides ACT-UP is, by our estimation, instrumental in the revival of a popular post-cold-war left. While British-born Jay came to his activities as an artist, French-born Isa arrived in the UK as an academic interested in popular education. Together they founded the LABOFII, a popular education and collaborative arts collective that doesn't do projects, rather, they organize exploratory and participatory experiments in rebellion. They bring artists and activists together to design disobedience. They find ways to live on the edge of art institutions and popular movements that catalyze the carnivalesque as resistance, for instance at G8 and UN Climate Summits, including using clowns, boats, ants, gaming, and bikes.

As is detailed in this book's pages, it was the exhausting episodic and ephemeral nature of these kinds of struggles that drove the authors' desertion of the city and drew them to the zad, where a very different way for art, learning, resistance, and doing life in common was possible.

The magic of the zad is its impossible but actual victory that here is accounted for. This book shows us how this victory stems from attention to zones' birds, frogs and from the day-to-day and also ritualistic ways its people and networks collectively organized to live there. These things were as much a vital part of the diversity of tactics that allowed the zone to defend itself as the dramatic and combative forms of solidarity that had made headlines. Just because winners get to write authoritative history, we should never assume that other ways of living, being and understanding have evaporated below their victory. Insurrectionary imagination springs from somewhere. The textures of the Black, Brown, Indigenous, queer and feminist, entangled and anarchist, and weird lives we lead constitute a rich set of values, ideals and practices for meaningful and complex beautiful forms of existence. The marginalized are so defined because their stories don't officially count, not because they don't exist.

In this context, the inspiration provided by the Zapatistas' intergalactic communiques cannot go unmentioned. They demonstrated that other histories were never annihilated, only hidden from the world. But now, more than 25 years after their inspiring uprising in Chiapas, we are witnessing a subtle generational shift on the wild, more queer,

and communitarian side of the anarchist left. Today, the spirituality of Starhawk, horizontalism, and the carnivalesque urban politics of Chris Carlsson are being supplemented by the more heterogenous, socially embedded and also systemically political ideas like adrienne maree brown's emergent strategy, Dean Spade's approach to mutual aid and the Care Collective's focus on the communalization of reproductive labor.

This generational/perspectival shift in radical praxis, knowledge, and community occur as capitalism and its world-ordering collaboration with the most regressive of spirits demonstrates its knowledge that climate change heralds a possible end of worlds—its worlds. So, beside this apocalyptic vision, the social knowledges and practices of those whose worlds already ended or were never properly allowed to begin, emerge as capable of reflecting what we have always-already known. Like the emergent anarchist cantons of Rojava, one thing that this book demonstrates is how eco-feminism is a consequential politics. The struggle of the zad also recalls the movement against the Dakota Access Pipeline (NoDAPL) led by the Standing Rock Sioux of the territories currently known as North and South Dakota. But where both struggles thrive on complex entanglements and solidarities, the zad is an experience of coming into a territory, rather than reconstituting intertribal and intercultural resistance and negotiating sovereignty.

In a neoliberal world, 'art' falsely promises its privileged subjects a sense of moral and political autonomy. In contrast, the zad was playing its own game and acting so that the French state could not

but recognize their autonomy. For this reason, I initially made editorial suggestions that it was the zad's culture that mattered in a way that needn't be defined by artistic dimensions. Its culture attended to questions of remedying imbalance, of cultivating entanglement; mirroring a sensibility informed by Donna Haraway and Starhawk. With so much goodness at play, why pray to the gods of art?

Art historian and biopolitics scholar Josephine Berry writes in conversation of art as "a conspiracy of reason." To take art seriously is to suggest that humans can, via emotion or intellect, move toward the right path. That art is a "conspiracy of reason" means that art's affective powers can so overwhelm consciousness that the speculative ideas and practices of art become widespread social practices, assumptions, and accepted facts of how life is lived. By calling their work "art," LABOFII insists that their work matters for the fate of this thing we call civilization. As Andreas Weber and Sylvia Wynter tell us in different ways, societies orient themselves by the stories they tell themselves. In that territory for living made between their zad victory and a studied attention to mundane practices for living is an artistic frame through which their art matters for all our sake. The authors focus our aesthetic attention on how entanglements can facilitate and constitute political transformation, *and* they have done the experiments to prove it in Brittany. So, for the sake of art and its conspiracy, this is notable. For arts' sake, I have sought myths to frame the zad's collective transformational artwork: the camel passing through the eye of a needle, Persephone's

annual passage from the underworld to ours, the transition of characters in the Mayan Popul Vuh. Instead of landing on a single individual, who could stand as a metaphoric model, I realize that what the LABOFII has done here is describe a sensibility to recognize and utilize the portal—the transformational portal.

Magic happens. Change happens. Between the many moving parts, LABOFII suggests one of many artistic sensibilities for finding a way to the other side, helping us navigate massive civilizational challenges and our being trapped in a history written by butchers. But the witches they failed to kill have already faced the ends of their worlds and lived to tell it. And, as Octavia Butler tells us, god is Change.

The cosmopolitical, the radical and the radically queer is entangled throughout the rich sociality of all life and its relations. To properly rebalance those entanglements toward something transformative and sustaining is an art and a work for our day. Recognizing that LABOFII has shown us this is possible, *The Journal of Aesthetics & Protest* has maintained a deep interest in copublishing this book over the years. In that effort I'd like to thank Sam Gould for his early publishing collaboration, Stevphen Shukaitis for his speculative writing related to the project, Amber Hickey for her strategizing, Jonas Staal for supporting some of the project research and Steve Lyon for his late help. Finally, thanks to Max Haiven for his fully collaborative editorial efforts and Jay and Isa for so much.

The lighthouse built where they wanted to construct the control tower. Jay Jordan, 2018

VĀG
ABO
NDS

Tempests

Let's develop our power to tell yet another
narrative, another story, if we manage, we will
delay the end of the world.[1]

> Ailton Krenak, journalist, philosopher,
> and Indigenous movement leader,
> of the *Krenak* people

These are messages written during converging
global storms, and as one should do during a
shipwreck, we begin by giving you our coordi-
nates: 47.3527° N, 1.7300° W.

But if you would rather find us without these
noxious eye-in-the-sky measurements of empire,
then just follow the water. Go up the rivers Vilaine
or Loire and you find 9 tributaries. Trace any
one of them to its source and you will arrive on
a thin backbone of clay that rises between these
watersheds and in the midst of a labyrinth of
hedgerows you will arrive at the place from which
we write, the place that has transformed us, the
place that has become us: The zad—*the zone to
defend.*

Walk through the marsh, beware of the orchids,
past the *Bollywood* dome, take the path up the *Rouge
et Noir* collective gardens with its greenhouses and
earthen cabins, pass the stone farmhouse of *les*

Fosses Noires. You might smell fresh bread from the bakery. Keep going down the road that still bears the black traces of where there were once burning barricades all the way to the crossroads. In the distance you will see a strange lighthouse peeking out of the hedgerows. Head toward it. Now turn right at the communal library and welcome center. You've arrived: Welcome to *La Rolandière,* our living collective. In the garden you will find half a dozen cabins and caravans. Ours is the one with a big tin roof which the wind is clattering acorns across. The wet west wind you feel rises from the sea that caresses the land 50km away. The huge grey salty skin of the Atlantic has worn down ancient mountains for eons, sculpting this granite peninsula known as Brittany.

When, five years ago, we moved to these 4,000 acres of threatened wetlands on this far western edge of Europe, we were seriously lost. The coordinates by which we had navigated our lives seemed no longer relevant. The two of us had spent a quarter of a century living in London, we were artists, academics, and organizers. Together we established *The Laboratory of Insurrectionary Imagination* in 2004 as a collective to co-design and carry out forms of resistance that tried to be as joyful as they were effective. Our lives were dedicated to multiplying edges of all sorts. The points where a forest meets meadowland, or the sea slaps against the shore are the most dynamic parts of an ecosystem. It's in those slithers of space that a multitude of different species coexist, and the engine of evolution moves fastest. Our favorite edges were between art and activism,

pleasure and protest, cultural institutions and radical social movements. Possibility emerges in those magical spaces of neither nor, the trans spaces, the non-binary worlds, the entangled hedges and edges.

But something felt wrong. We felt split inside.

Many of our elders, from the Dadaists to the Situationist International, had taught us to totally entangle art, everyday life, and politics. Isa had been part of the crowds flooding London's financial center one hot Friday afternoon on June 18, 1999, during *Reclaim the Streets'* "Carnival against Capitalism." It was one of the first global actions coordinated on the then new Internet and simultaneous carnivals erupted in 40 different countries that day, from the Ogoni and Ijaw lands of Nigeria to Belarus, from Uruguay to Nepal. Isa had not yet become involved with movements and, despite her love for teaching, was already doubting the political usefulness of the academic path she had just entered. JJ, who back in the 80s identified as a performance artist, had already escaped from what art critic Suzy Gablik[2] calls "the prisons of the art world," where radical ideas are tolerated so long as they remain confined there and don't spill into real action. He had begun to dedicate his creative energies to direct action movement organizing, which for him merged the aesthetics of the body pushed to limits of performance art and all the dramaturgy of total theater. Little did Isa know that day that JJ was part of the crew that co-designed the choreography of the carnival, distributing 8,000 colored masks to rebel bodies (like hers) to outwit the cops[3] and enable an

invasion of the London International Financial Futures Exchange, known sickeningly as LIFFE. That riotous carnival was one of the warm-ups to the alterglobalization movement that took the spotlight six months later in Seattle, by shutting down meetings of the World Trade Organization. Four years later we fell in love sharing our adventure stories of those unforgettable days.

The day after the carnival, the front-page headline of the *Financial Times* read "Anticapitalists Besiege City of London." We were exalted. But even 20 years ago we felt a toxic pattern repeating. As the adrenaline of those days of rage would wear off, a fissure seeped in sadness would grow inside us. We would always return home to an everyday life still besieged by capitalism. Our forms of life would continue to nourish the extractivist logic of the capitalist metropolis. We had to do something before the fissure became an abyss. And so we deserted, for something very different.

* * *

We finished this pamphlet in the summer of 2021, a year since COVID-19 joined the convergence of storms. Spread by jetsetters and felt by the most vulnerable, the virus became a global X-ray machine, revealing deep inequalities and giving us a grim glimpse of a future of algorithmic management imagined by surveillance capitalists. But the pandemic also transgressed the modern separations between 'nature' and 'culture,' bringing us violently face-to-face with

the reality that we are not the bounded, solid homogenous individuals that modernity describes us as. Rather, we are assembled beings, sharing an inter-dependent inter-relational life with human and more-than-human others. The myth of the selfish, competitive individual who is separate from worlds they inhabit is collapsing. In the pandemic, many people were prepared to radically change their behavior to protect others. Underlying the practices of masking, shielding and distancing, we saw the basic principle of the living world and of commoning embodied: each individual can only live if the collective, which she constitutes with all others, is able to flourish.

As for our bodies, the pandemic reminded us that the *I* is never a constant, but as biologist Lynn Margulis tells us, "a fine environment for bacteria, fungi, roundworms, mites and others which live in and on us."[4] Life is a squirming, swarming, transforming collective of bodies nested within bodies. "There is only one immutable truth," writes biologist and philosopher Andreas Weber, "no being is purely individual; nothing comprises only itself. Everything is composed of foreign cells, foreign symbionts, foreign thoughts. This makes each life form less like a warrior and more like a tiny universe, tumbling extravagantly through life."[5] We now know that more than half of our body is not human.[6] One in five of all our genes originated as a virus infiltrating itself into our DNA.[7] The total entangled interdependence of life became more tangible as the image of the novel coronavirus burned itself into our imaginations and became an icon of this epoch that marks

the end of a world . . . and the intake of breath before something else.

The storms in the Atlantic Ocean have been so amplified by the climate wreckers of industrial capitalism that they can now be measured on seismographs. The walls and fences built to stop the freedom of movement of people, are now exactly the circumference of the earth. By the time you wake up tomorrow over 200 species will have been pushed to extinction.[8] We know far too many of these apocalyptic stories with their deterministic endings. We long for stories of victorious struggles—this pamphlet is one of those rare stories, and it is about our home, on these wetlands, where a 40-year long struggle was won. But it is just one version of that story, and others who lived through it would tell it radically differently. Of course, it is full of holes. But perhaps one day, in a lull between the storms, we will fill in the gaps together while walking with you through these lands.

At times you may feel a bit disoriented reading this story, wondering whose voice is speaking. Two body-minds and four hands have typed these words, at times we speak as 'I', sometimes as 'we', jumping between third person and first person. In an epoch where bounded individualism is no longer a desirable or even rational position to think with, this fluid perspective makes sense to us, and we hope for you to.

The storms are always coming, poet and activist James Baldwin reminded us, but the challenge is not so much to get through them but "to bear witness to something that will have to be there

when the storm is over, to help us get through the next storm."[9] We hope this pamphlet can be a reminder that fighting and creating is never futile, and that hope is not about knowing what is on the horizon, but taking the courage to leave port despite uncertain weather.

Part I: Seeding

Scream

Her hand rises up out of the swirling sea. Dark eyes fix deep blue sky. She's drowning, not waving. Water is pushing life out of her lungs, but she just wants to be alive, she coughs and squirms. She's traveled so far to get here. Her home is on fire, her land has been stolen, the climate has broken down, droughts have brought hunger, the fields are becoming deserts, the wars never stop, and she is in search of life, that's all.

But Fortress Europe has made sure she never reaches the tourist beaches with their bronzing bodies and sweet smell of sun cream. Her darker body will wash up on the golden sand days later, when the tourists have gone back to their hotels and after the tides are tired of playing with it. You are moved by the TV pictures of the crowded boats and the drowned children. You are moved to make a work that speaks of how Europe's migration policies are killing the exiled. You cover the columns of a theater with thousands of orange life jackets.

You are the artist Ai Weiwei.

When asked why you helped design Beijing's Bird Nest Olympic stadium for the very government that has repeatedly repressed and

censored your work, you replied that it was because you "loved design."

Do you love art and design more than life?

* * *

The Arctic is at times 20 degrees Celsius warmer than it should be at this time of year. The ice is melting so fast. What would normally be happening with the long slow geological time is happening within the span of your life. The waters are rising and many of the climate tipping points have passed.

You feel you have to act. You have hundreds of tons of artic ice that has broken off the ice shelf transported to Paris during the United Nations Climate Summit in 2015. You leave them to melt in the street.

You are the artist Olafur Eliasson.

You say your studio does not "make things" but "ideas", which does not stop you selling your wire and lightbulb football lampshades for £120,000 to rich collectors.

You are artists and you are working in the Capitalocene, an era marked by a system, whose obsession with limitless growth means it will always place the economy in front of life, sucking the living into its globalized circuits of capital, forever expanding and voraciously devouring more and more worlds. Some biologists call humans "the future eaters."[10] But to blame 'humans' is to let the real culprits off the hook: only 20% of humanity consumes 80% of the world's resources.[11] A recent official European Commission policy paper ended

with the warning that if we go beyond 1.5 degrees of warming, "we will face even more droughts, floods, extreme heat and poverty for hundreds of millions of people; the likely demise of the most vulnerable populations—and at worst, the extinction of humankind altogether."[12] The least responsible for the climate-wrecking emissions are the worst affected by it.

We are living in a war against the poor. We are living in a time where it is easier to imagine the collapse of life as we know it than reinventing the right ways to live together. We are living on the edge of an epoch.

No artist or activist has ever had to work in such a moment in history, and yet our culture continues to turn its back on life. Business as usual is the order of the day, especially in the museums and theaters of the metropolis. We could call it extractivist art. Extractivism takes 'nature,' stuff, material from somewhere and transforms it into something that gives value somewhere else. That value is always more important than the continuation of life of the communities from which wealth is extracted. So many artists make a career out of sucking value out of disaster, rebellion, animism, magic, whatever is a fashionable topic at the time, and regurgitate it into un-situated detached objects or experience elsewhere. Anywhere in fact, as long as the codes of the world of art function.

If your artist CV says you've shown in Cape Town, Dubai, Shanghai, and Prague and live between Berlin and New York, you have value. But if your bio says that you work in the village where you have lived all your life, getting to know

the humans and more-than-humans who share your territory, and that your work nourishes local life, your career is fucked. Under capitalism, mobility is always more valuable than getting to know and paying attention to somewhere. We are discouraged from being attached to anything or anywhere, except perhaps to our careers or to our lofty rhetoric and detached radical theories. Words and ideas that rarely have consequences, rarely translate into transforming worlds. To be attached to something material and relational is dangerous because it means you might fight to defend it.

The Intergovernmental Panel on Climate Change, the UN climate scientists not known for their revolutionary spirit, wrote in 2018 that if we want to avoid the worst of the catastrophe, we had 12 years left for "rapid, far reaching and unprecedented changes in all aspects of society."[13] We must revolutionize so much of our existence, and fast. This must include art, which for far too long has been perceived as the very ground zero of what it means to be 'civilized,' human even.

Art-as-we-know-it is an invention. Manufactured by the white European colonial metropolises, it is only a little over 200 years old. It arose hand in hand with the beginnings of industrial capitalism, it rested on the same philosophical myths that enabled extractivism everywhere: the toxic dualisms between nature and culture, mind and body, individual and common, art and life.

Art-as-we-know-it was just one more weapon of separation to exclude the poor, the rural folk, the craft people and popular culture of all

shades, from the calm contemplative spaces of the rising metropolitan monied class. With its cult of individual genius, exported around the world to teach everyone the great supremacy of the white European imagination, Art-as-we-know-it became the pinnacle of humanity.

Two centuries on, many are still caught in the trap of Art-as-we-know-it, representing the world rather than transforming it. Showing us the crises rather than genuinely attempting to stop them or create solutions. It's as if someone had set your home on fire and instead of trying to extinguish the blaze, you took photos of the flames. What kind of separation must have to take place in our minds that when faced with such an existential emergency we think only of representing it? And whom do such "pieces" serve, ultimately?

Why make an installation about refugees being stuck at the border when you could codesign tools to cut through fences? Why shoot a film about the dictatorship of finance when you could be inventing new ways of moneyless exchange? Why write a play inspired by neo-animism when you could be co-devising the dramaturgy of community rituals? Why make a performance reflecting on the silence after the songbirds go extinct when you could be co-creating ingenious ways of sabotaging the pesticide factories that annihilate them? Why make a dance piece about food riots when your skills could craft crowd choreographies to disrupt fascist rallies?

Why continue with Art-as-we-know-it, when you could desert this Nero culture, which fiddles while watching our world burn?

Disobedient Desires

We may see the overall meaning of art change profoundly—from being an end to being a means, from holding out a promise of perfection in some other realm to demonstrating a way of living meaningfully in this one.[14]

Allan Kaprow, performance artist

Every form of collective action we know—boring A to B marches to barricades, hunger strikes to boycotts, flash mobs to occupy camps—emerged out of the coordinated imaginations of people in struggle. Many of those who pursued these tactics knew that disobedience is what makes history. From the right for women to wear trousers to the legalization of contraception, from the work-free weekend down to the fact that you can read this independently-published (and not government censored) pamphlet, all these 'privileges' were the result of people disobeying the laws, and often the norms, of their epoch.

When we found one another, we also found we shared this conviction, as well as the knowledge that for radical action and disobedience to take hold of the imagination and become meaningful, it also needed to be deeply desirable, changing our worlds had to be as joyful as it was irresistible. Within months of meeting each other, we launched the *Laboratory of Insurrectionary Imagination* from an East London squatted social center. We wanted to bring artists and activists together to co-design tools of disobedience. The artists would bring imagination and poetics, and the activists

would bring courage and context. The formula worked, especially when sprinkled with some of the key ingredients of rebellion: passionate pleasure and adventure.

Over those years you might have found us at a Climate Camp in Kent distributing pirate maps to indicate the location of buried boats with bottles of rum, ready to launch a mass rebel raft regatta to shut down a coal fired power station. You might have heard of the scandal that ensued when we refused to let London's prestigious Tate Modern museum censor our workshop that dared to do more than 'reflect' on the relationship between art and activism, and instead acted against the museum's fossil-fuel sponsors. Maybe we met you at the Kampnagel summer festival in Hamburg, where we turned a stage into an assembly space to decide on the ethics of leaving the theater and injecting ants that sabotage computers into the city's fossil-fuel financing banks. Maybe we crossed paths during the protests at the Copenhagen UN climate summit when we were transforming hundreds of abandoned bikes into tools of disobedience, to protect a public assembly of Indigenous and Global South climate justice activists from police violence. Or perhaps you were a player on one of the 120 teams participating in *The Climate Games* we coordinated in Paris, defying the State of Emergency and ban on demonstrations, with the slogan: *We are not fighting for nature, we are nature defending itself.*

All these experiments had something in common: they were based on direct action. We weren't protesting, we weren't begging, we

were taking life back into our collective hands, unmediated, material, now. Often, those that govern are flattered that there are protests, that people make demands on them: it legitimizes their power. "Protest is begging the powers-that-be to dig a well" wrote our late friend, the radical anthropologist David Graeber. "Direct Action is digging the well and daring them to stop you." It is what he called "acting as if you were *already* free."

Despite the collective joy and the victories that resulted from many of the movements we were entangled with, we often felt a kind of emptiness in between the adventures. Like a sort of activist comedown. It took years to realize that perhaps this was linked to the fact that these actions somehow never seemed totally embedded into our everyday lives. They felt separate from the neighborhood that we lived in, as if floating above our daily needs. We were radical activist artists, but we still had that sensation of being detached from worlds, moving from one place to another, from event to event, activist camps to theater festivals, giving conferences in one place, teaching in art schools in another, shutting down an open cast coal mine elsewhere, always returning to the suffocating concrete of London, where home had become a mere landing pad. Like so many captured by the metropolitan logic, we were body-minds without anchor, we were discombobulated beings who had lost any true sense of place.

It would only be here on the zad, defending this threatened land from the spread of the metropolis, that we began to feel what it meant to be truly free and that meant being caught up in the necessities

of a shared everyday life. When you become attached to somewhere, when you realize that you can become the territory, freedom no longer floats in the air but lives in the relationships and the ties of need and desire that you build. We fell in love with this place and its rebel inhabitants and thus became free to overcome fear and put our lives in the way of those who wanted to destroy what had become our home. And when we let ourselves do that, we discovered that the more we inhabited this place, the more it inhabited us.

Following Swallows

Compost toilets should always have good views; ours is exceptional. Especially at this time of year, as the golden autumn sun tunes itself to the colors of the meadow. With the deep green edge of the forest as a backdrop, the long flat field becomes the stage for a final aerial ballet show of swooping swirling barn swallows preparing to migrate, 10,0000km away from this western edge of Eurasia all the way to West Africa. This theater's best seat is right here, in our living collectives toilet, where, daily, our bodies return some of their nutrients back to this land that nourishes us. We could watch the swallows' duets with the air for hours.

They glide, flutter, then dive, opening and closing their wings with a lightning snap, their tiny white bellies caressing the grass as they skim the ground feasting on insects before speedily spiraling up to join their fellows, high in the sky chirping shimmering sounds of pure pleasure together.

"It must be a sort of farewell ritual," says our self-taught ornithologist friend Alessandro, who deserted his profession as a cognitive scientist to pen graphic novels. We are eating lunch outside, 20 of us, young and old, around the long oak table. It's one of the forms of life we love most here. Every day we eat with a set of different people, there are always folks from our living collective but also a steady stream of visitors, from other collectives and from afar. We laugh, tell stories, make jokes, discuss political strategies and construct the warm conviviality that cements common life. "Perhaps the swallows know that not all of them will make the long journey," Alessandro continues, looking dreamily into the agitated air. "Maybe it's a kind of goodbye party." Soon these swallows will depart for their six-week flight heading south to West Africa. For centuries, folk in Europe could not understand where the swallows disappeared to at winter; some thought they spent it on the moon, others that they buried themselves underneath lakes or in the mud. Today, scientists have made detailed maps of their migration patterns, they resemble the maps in airports, colored trails crossing continents. But these fragile threads of swallow journeys following the jet streams that form as land, water, and air meet, could not be more different; their flights don't flood the air with climate wrecking toxins. Many swallows die as they make the long crossing of the Mediterranean, but at least they can ignore the militarized borders and razor wire fences of Fortress Europe. Swallows still live in a world without states, borders and papers, just as we humans did for most of our

history, moving from one place to another in a slow rhythm of traveling and settling, leaving and arriving.

The storms sweeping the Sahara stirred up by the wrecked climate are more vicious these days, and many of the swallows' tiny bodies won't make it. Here in France, spring routinely arrives a week earlier than it did 30 years ago; normally the swallows base their arrivals and departures on the availability of their staple food: insects. If they mistime their journey they starve, especially as the insect populations are already plummeting because of the agro-industrial use of pesticides and insecticides and the destruction of hedgerows to make way for 'development.' Over the last two decades, more than 40 percent of the swallows in France have 'disappeared'; or rather been sacrificed to capitalism's gods of the growth economy.

When the swallows leave us each year for their migration, the sky is suddenly quieter, less alive. This year, we sense a strange feeling of loss. Their absence becomes so terribly present, just like when a loved-one dies. We know that the birds will return in spring, but in their departure is a shadow of a deathly future, a prefigurative feeling of this world if they went extinct. Without them, there would no longer be the joy at watching and recognizing that force of 'yes' in their flying bodies, that desire for life which we share with them and all other beings. When a being goes extinct, a bit of us is lost as well.

Of all our feathered friends on this land, swallows are the most woven in with our human

lives. Not because of their inspiring aerobatics, but thanks to their down-to-earth architectural artistry; they construct small cupped mud nests attached to our buildings. In fact, before humans invented buildings and barns, around 8,000 years ago, there were no barn swallows. But at some point, differentiation occurred, and the subspecies of barn swallows emerged. Virtually genetically identical to their relatives, but with very different behaviors, including the ability and preference to build nests on human constructions rather than in the folds of cliffs. Today, they are the most widespread and successful of swallows. Biologists hypothesize that the entwined relationship between humans and barn swallows stemmed from a 'founder event,' when a little gang of adventurous rebels decided to occupy a brand new environment that had been transformed by humans and expanded their new population there, thanks to available resources and an absence of competitors. Species differentiation is normally seen as a long-term process lasting up to a million years, but barn swallows demonstrated how rapidly it happens when the conditions are right.

Watching the swallows' grace and ingenuity, surfing air and sculpting mud, we realized how much they could teach us about an art of life in these trembling times. Their foundation story reminds us that transforming our worlds often means taking the risk of deserting the comfort of what we know and pursuing an adventure toward what we don't. The swallows teach us to arm ourselves with the ability to adapt to change, while

holding on to the core of who we are and what we want. And what we want is life.

Extinction Machine

What the birds thrilling us that lunchtime likely did not know was that the land over which they danced might have become the runway of an international airport. These meadows and forest should have been covered in tarmac and filled with roaring metal flying machines, taking off and landing day and night. The garden where we were eating would have been the departure lounge, and instead of the well, there should have been the border controls with their dour guards and screeching metal detectors.

If the French state, together with the Vinci corporation (the world's second largest construction multinational) and local business elites had had their way, these 4,000 acres, with their farmland and forest, nine springs, over 200 ponds and 222km of hedgerows, would have been sucked dry, paved over and disfigured into another model of 'development': a massive new international airport to replace the existing and 'award winning' one in the nearby city of Nantes.

Without the emergence of an incredibly creative diverse trans-local but profoundly situated and anchored struggle, the dawn chorus that wakes us every morning would have been replaced by the deafening growl of jet engines. Instead of the sweet smell of summer hay, the winds would be wafting the sharp reek of kerosene. Instead of providing healthy local food, this place would

pump out climate-wrecking molecules. Instead of carbon-sequestering pastures and wetlands, a shroud of concrete and tarmac would have smothered everything. Instead of absorbing and storing the rain, cooling the land, and regulating the hydrology of two major river systems, this place would unleash more local flooding and toxic runoff into the valleys far and wide.

With their bulldozers, they thought that they could destroy the complex relationships between the millions of beings that share these lands. They thought they could erase the ties between the peasants and their meadows, between the oak tree and the fungi that they share their minerals with, between the woodpecker and the wood worms that help it dig its nest. They dreamed of building another temple to hypermobility, another extinction machine whose bad breath spreads droughts and death, famine and flood; another airport. This place could have become yet another non-place like all the others, erasing all the human and more than human communities and stories that were unfolding here before, destroying everything particular and special about this land and its inhabitants. The salamanders, frogs, hawthorn, farmers, blackthorn, newts, water voles, dragon flies, deer, orchids. These prairies and forest would become no different to the runways of Heathrow or JFK, Dubai, or Frankfurt, bordered by the same duty free shops smelling of the same sickly perfume, the same chain stores and takeaway coffee stands catering for the detached metropolitan beings, 'based' somewhere but inhabiting nowhere. Flying

between the same hotel rooms and conference halls, the same offices and museums, the same biennales and bars. Reproducing a globalized homogenized culture uprooted from everything that counts: from land and community, from food and dwelling, from our own bodies and those of all the other living beings we share our life with; what Indian physicist and activist Vandana Shiva calls the "monoculture of the mind."[15]

Like many future-eating machines these days, the airport would, of course, be greenwashed. Despite contravening EU wetlands preservation laws, its design was awarded a 'sustainable development' label, thanks to its unique architecture and complex eco-compensation schemes to offset the devastation of local species. In fact, according to the architects, the infrastructure would blend so well into the landscape that it would be as if nothing had changed: with its green living roofs, it would just feel like "a part of the bocage rising up."[16]

The bocage did indeed rise up, but not in the way they would have hoped.

Rebel Bocage

The bocage is the name for this increasingly rare type of landscape sculpted by two centuries of collective peasant life, planting hedges, digging ditches, tending pastureland and creating a checkerboard patchwork of small fields, crisscrossed by kilometers of hedgerows and little forests. Its network of ditches and ponds were designed to keep the water of the wetlands flowing and to

stop erosion and flooding. Its polycultural mix of milking cows and fruit trees provided the conditions for a fairly autonomous closed-loop agriculture, with little need for imported resources and not much waste. This landscape is neither just wild nor just farmed, but both; it has been cocreated by human and more-than-humans over generations.

It is not a sublime landscape, there are no deep valleys or mountain tops, it is fairly flat, and the hedgerows block any romantic vistas. But as the retreating Nazi troops realized to their detriment in Normandy, bocages are very good for ambushing your enemy. A small village, Notre-Dame-des-Landes (Our Lady of the Moorlands) lies to the north, to the south the urban sprawl of Nantes begins with a sea of suburban housing and gigantic commercial centers.

Like most of Europe following the Ice Age, this land was once deep forest that its Neolithic human inhabitants slashed and burned, a practice that left low-fertility moorland in its wake. For thousands of years these moorlands were managed as what we would today call a 'commons': the land and its uses were cared for collectively through a culture of mutual aid and users' assemblies in order to ensure the long-term flourishing of both land and community. The land provided enough food and subsistence for the communities that lived here until the rise of capitalism and the enclosures of the eighteenth and nineteenth centuries when the commoners were evicted from their source of collective livelihood and transformed into wage- or debt-dependent workers. Their commons were

turned into machines of 'economic production,' growing crops or raising animals to be sold at distant markets for someone else's profit. Enclosure was carried out in part by planting hedgerows to subdivide the land into small private fields, which now gives the bocage its unique checkerboard look.

Our predecessors resisted enclosure for over 200 years. The commoners pulled down the fences, filled in the ditches and at one point hung a landlord effigy with a sign warning "this will happen to those who destroy our commons."[17] But faced with overwhelming odds and a radically transforming economy, the struggles failed. Those who were deemed ungovernable and unproductive by the metropolitan capitalists and their state apparatus became subject to capture and control.

As the eighteenth century progressed, Nantes became France's main slave port, accumulating wealth with the 'triangular trade' which saw over 12 million Africans enslaved to work on Caribbean sugar, indigo, and coffee plantations. The excess capital flooding in the pockets of the bourgeoisie needed to be invested somewhere. Waves of privatization followed, enclosing nearby moorland which was seen as terra nullius wasteland and needed to be rendered 'productive' to the 'economy.' The extra fertility was brought in via a by-product of the sugar trade.

Then another form of remodeling the landscape to capture it some more for capital unfolded across France. From 1914 to the 1990s, in several waves of what was called the *remembrement*, bocages were bulldozed and leveled, leaving unrecognizable

landscapes made up of large open fields tailored to the industrialization of agriculture, dependent on fossil-fuels, toxic pesticides, and imported fertilizer. The destruction of the bocages marked the end of local subsistence peasant agriculture and the locking of farming into the logic of global capital, based on maximizing profits for the agro-industry and often plunging farmers into debt. The irony is that the airport project here somehow 'protected' the bocage of Notre-Dame-des-Landes. The land earmarked for the airport was put into a kind of legal time capsule, waiting decades for the building to start. The airport was first planned in the 60s but put on and off by the whims of politicians and market. As it was meant to be eventually concreted over anyway, there was no need for any *remembrement*. This landscape is thus a certain palimpsest of capitalism's stages of emergence, with its layers of extractivism, enclosure and colonial violence.

Thanks to the artfulness of the airport's architects, the memory of this bocage was to remain after its annihilation in the form of special herb gardens set next to the two runways, planted in squares of different colors, which, according to the project's glossy brochure, would "remind us of the geometric surfaces framed by the hedgerows, yet without them." The plan included the replanting of some hedgerows to line the new motorway that would serve the airport and divide up its acres of parking lots. But, due to the danger birds might pose to airplanes, care would be taken to ensure the trees used would discourage nesting. To certify their airport as 'green,' the project

would employ a form of 'biodiversity offset,' to compensate for the nefarious impacts of the project, in the logic that turns life into equations and sustainability into a game of math. For every pond destroyed, two would be built elsewhere, and a few samples of the rarer species of animals and plants would be collected and moved to new homes.

Behind our compost toilet, looking out to the ghost of the runway, stands a farmhouse. Like most of the communes and collectives that now inhabit this land, we built into this one special swallow doors that let them into the buildings. Often, they swoop over our heads during assemblies that co-decide life here, flying in and out to feed the chirping hungry chicks in their nests. Made of spit and mud, defying gravity hanging off the beams holding the weight of numerous babies, these swallow buildings don't require engineers' measurement, architects' designs, or planning permission. They are dwellings built with sensing bodies, generated by the specific axioms of the space they inhabit, they are pure sense and situation, every one unique, the result of a deep presence and awareness of how a material feels, a deep direct attention to things, a totally embodied form of home making and inhabiting.

An art of life.

Part II: Germinating

Departure Lounge

How did the two of us land here, living in a squat on this rebel bocage where there 'should' have been an airport, deeply enmeshed in a form of shared life that attempts to dissolve the separations between art, activism, and everyday life? Our journey has as many beginnings as potential endings, but let us begin 13 years ago, in 2007, on another airport runway. We are not taking off in a plane (we have boycotted air travel since we met in 2003)[18] but sitting in a circus tent. We are part of the organizing group of the Camp for Climate Action and, together with local villagers, creeping through the fields in the dead of night we have just occupied the site where Heathrow Airport's third runway is planned. If built, the project would destroy several villages on London's edge. Its single strip of tarmac alone would produce the same amount of carbon as all of Kenya.[19]

We are at the UK's second ever Climate Camp and thousands of people have been squatting this land for a week. Isa and I have spent an intense year co-organizing and facilitating this, doing comms, media work, art activism trainings, and more. Like all our friends in the organizing collective,

we are on a high. Despite the UK's biggest ever legal injunction against us, we still managed to take the site and set up windmills, solar panels, collective kitchens, a sea of tents, pedal powered Internet café, and cinema. And, of course we have compost toilets with their own special views, this time of the airport's control tower and planes taking off a mere 500 meters away.

These temporary occupations acted as stages to highlight the root cause of the climate breakdown, capitalism, while illustrating other possible worlds. The dramaturgy of climate camps in the UK has always been carefully considered. The 'problem' of the airport appears as the backdrop, and the 'solution' takes center stage: a grassroots, self-managed, nonhierarchical, low impact (temporary) community. The previous year's camp was planted in the shadow of the colossal grey chimneys of the Drax coal-fired power station in England's far north, Europe's largest emitter of CO_2. This year's location is less visually ominous, but very noisy. Somewhere between protest camp, popular university, and music festival, the camp is home to science workshops, dance parties, and long assemblies to organize life and direct action together. All along, a multitude of actions against the airline industry are plotted for the day of action, the final act of the camp. In the center, stands a majestic circus tent whose canvas sides gently breathes in and out with each gust of wind blowing across the pancake-flat field. On its roof hangs an enormous banner, big enough to be seen by the planes flying overhead, reading: *This planet has no emergency exits.*

On the first night of the camp, the tent was packed to the brim for the opening assembly, the atmosphere supercharged. Our friend Oli picked up the microphone and made a speech whose words would become a compass for our journey for years to come:

It's really important, as we deal with the necessities and the huge scale of the changes that are needed, that we remember that we have to keep dreaming about the world that we want to create, because only by keeping our focus on that horizon will we be creating the world that is actually better than this one, and that combination of dreaming and determination to fight is what is going to carry us through. What is more and more necessary is that we withdraw consent and our participation from the current economic system [the crowd cheers] and there is no single answer to how that's done, that's down to every single person to look at their role in the economic system and start saying "how the fuck do I get myself out of this—and fast?"[20]

"How the fuck, indeed?" This was the question we'd been asking ourselves for a long while. At that time, we were living in an old shopfront transformed into a flat in Bethnal Green, East London. Isa was senior lecturer in Cultural Studies and JJ had left his job as senior lecturer in Fine Art in 2004. Although JJ's grandfather had been brought up in the neighborhood when it was an infamous slum, a century later we found ourselves part of the white colonizing gentrifying class of

'creatives.' By living there, we were inevitably joining an army of displacers with their stylish bohemian bulldozers camouflaged as boutiques, and the wrecking machines of expensive coffee bars, coworking spaces and art galleries. Fueled by bankers and property developers, the eviction machine was pushing out longtime locals and poor residents by driving up rents and property prices. We were contributing to turning this once richly diverse working-class neighborhood into another homogenous hipster enclave, just like Brooklyn or Kreuzberg. Despite being involved in local antigentrification struggles, we knew that as cultural workers it was impossible to live in a city in the 'Global North' without nourishing the monocultural monsters of gentrification.

Behind our flat were workshops where artisans had been working to finish furniture since the nineteenth century when the neighborhood was a hotbed of trade union and anti-capitalist militancy. When we moved in 2004, artisans were grinding, chiseling, sanding, and varnishing just like their predecessors. By the time we left a decade later, their workshop had become a luxury flat for an 80s rock superstar, the lead singer of Bananarama. "We were killed by IKEA," the furniture finishers said as they closed the doors for the last time.

For decades, we'd been denouncing capitalism and prefiguratively demonstrating other ways of living, inspired by the notion of Temporary Autonomous Zones (TAZ). Coined in 1990 by Hakim Bey, the TAZ aims to keep the creativity, energy, and enthusiasm of uprisings without repli-

cating the inevitable betrayal and violence that has been the reaction to most revolutions throughout history. The answer lies in refusing to wait for a revolutionary moment but creating ephemeral spaces of freedom in the immediate present. With Bey, we wondered: "Are we who live in the present doomed never to experience autonomy, never to stand for one moment on a bit of land ruled only by freedom? Are we reduced either to nostalgia for the past or nostalgia for the future?"[21] The *Reclaim the Streets* parties that JJ had been part of co-organizing, are a classic example. Such as when thousands illegally partied on a highway to the sound of techno, while hidden underneath the skirts of carnival giants, people dug up the tarmac to plant trees. So were the climate camps that evolved from these movements in the 2000s. Sometimes these actions made history: the G8 were forced to meet on mountain tops far from the rioting crowds and we saw coal fired power stations, motorway projects, and airport runways canceled.

But other times, it felt like an empty, repetitive gesture because our palette of tactics was not large enough, and our canvas of action was too big, too abstract, and somehow overwhelming. This episodic activism sometimes felt like an ineffectual circle, spinning around, detached.

First, we'd strategically choose a target: a summit, a new pipeline, or power station, etc. Next, meetings would take place and working groups would be set up. Then the action would happen, often an adrenaline peaked adventure that built great comradeship. But inevitably a

lot of time would be spent on legal work at the end to deal with arrestees. And the next year it would happen all over again. We got tired of the temporary nature of these cracks in capitalism that would so quickly close up. These actions would bring people together with a certain irre- sistible intensity, but this activism as 'event' felt too distant from our everyday life. We would always end up returning to business as usual, a return to jobs, the flat, the mortgage, the weekly organic food box subscription, the dependence on money, the nuclear family. We often felt a recurrent sense of dread returning to the metropolis afterwards, because we felt deep down in our gut that our form of life was feeding the very culture and system that we wanted to dismantle.

Desertion

Gentrification was but one of the noxious devices of the metropolis that we wanted to free ourselves from. There were many others, embodied in the layout of streets, the surveillance camera networks, shopping malls, the park designs, the cultural industries quarters—all capturing our body-minds and behaviors with its seductive logic that whispers: "here the artificial reigns over everything." The 'metropolis' is what you have when the modernization process is complete and 'nature' is flushed away, where everything is captured by the market. Everything is designed so that humans only relate to themselves, where only 'we' govern, produce, and create reality. This reality is shaped by the urbanists and architects,

planners and managers, executives and bureaucrats, in the likeness of the 'sky is the limit' gods of economic growth, where we are reduced to selfish individuals and manic consumers.

Embedded in the concrete, steel, tarmac, powerlines, and fiber optics, capitalism's ideology molds and controls all aspects of life, convincing us that there is nothing else. No other form of life, no other possibilities than *this*. And *this* is the materialized high point of progress. Development, efficiency, and productivity become the only possible goal of our species. Relationships are captured and commodified. We are split from our food sources, from our soil, from our plants, from our weather and water. The many worlds and beings that sustain our life become alien. We float, without body or territory, detached from everything in a dysfunctional co-dependent relationship with the economy. As philosopher farmer Wendell Berry sums up: "Educated minds, in the modern era, are unlikely to know anything about food and drink, clothing and shelter. In merely taking these things for granted, the modern educated mind reveals itself to be as superstitious a mind as ever has existed in the world. What could be more superstitious than the idea that money can bring forth food?"[22]

Of course, the answer is not for *everyone* to desert the city, 'go back' to the land and become a farmer. But we must desert the *logic* of the metropolis, which also forms much of the 'countryside' to its likeness: dousing fields with chemicals, planting monoculture forests as carbon offsets, imposing work-consume-sleep patterns, forcing

farmers into debt, and imposing computerized planting schedules. It is possible to reappropriate cities by finding cracks and interstices to rebuild commons based on solidarity and mutual aid that reconnect us to more than ourselves. Neighborhood assemblies can be organized to reclaim communities' collective agency. Workers' and housing co-operatives can be set up to lessen the grip of wage labor and circumvent private property. We can fight to defend squats that offer emergency housing and radical cultural and educational programs. Many are occupying what the metropolis designates as 'wastelands' and turning them into food producing fields. Others are weaving webs between otherwise individualized balconies and roof gardens to regain resilience and food sovereignty, as Havana has so successfully done over the last 30 years.

The metropolitan logic is even in the very division between 'city' and 'countryside,' a false distinction that revolutionaries, from anarchist geographer Kropotkin[23] to English artist, socialist activist, designer and poet William Morris, have worked to abolish. Recent archeological research has shown that there were civilizations without such a dichotomy. Over the past decades, the traces of vast decentralized ancient 'cities' dispersed across tropical forests have been uncovered. These Classic Maya and the Khmer societies of Cambodia were totally integrated into the forest and were some of the most extensive urban landscapes anywhere in the pre-industrial world— far outstripping ancient Rome, Constantinople/

Istanbul and the ancient cities of China. Their low-density design stretched across hundreds of kilometers, with complex forest gardens, water systems, and agricultural production for hundreds of thousands of inhabitants.[24] "The town, and the distinction between the town and the countryside, develop along with and after the development of the state," anthropologist Paul Clastres explained, "because the state, or the figure of the despot, immediately settles in a center, with its fortresses, its temples, its shops."[25] It's easy to forget how recent the idea of a centralized state power is. Until 400 years ago, one third of the globe was beyond its reach, political scientist James C Scott reminds us: "The state can be said to dominate only the last two-tenths of 1 percent of our species' political life."[26] It is a blip in history, but it feels almost impossible to escape.

We dreamed of waking up every morning in a place where secession from the system was a permanent process. Of course, every society needs its carnivalesque rebellions and short-lived eruptions to turn the world upside down, history is often made by such outbursts. But how could we maintain those momentary disobedient cracks throughout our everyday life? How could we overcome the separation between the way we think, the way we make art, the way we resist and the way we live our lives?

As the Heathrow Climate Camp packed up its tents, instead of returning home we got into a camper van and set off on a trip through Europe asking these questions and meeting communities

that had taken their dreams of other worlds and built communities to test them in the present. A book and fictional documentary film, *Les Sentiers de l'Utopie* (Paths through Utopias),[27] emerged from that journey. We met Serbian workers occupying their factories and a German polyamorous eco-village that had liberated love. We visited a permaculture settlement in Devon and an abandoned hamlet squatted by punks. We were blown away by the wisdom of kids in a Spanish anarchist school and the audacity of communist agricultural workers, who had evicted the police from their village and expropriated land from the duke. The journey ended in the liberated neighborhood of Christiania, in central Copenhagen, squatted in 1970 and now home to over 1,000 very diverse inhabitants. We returned to London, our imaginations stretched open by all these encounters. Their stories had showed us the many shapes of hope despite capitalism and it confirmed that we had to desert the Metropolis. By the time the book and film came out we'd redrawn the map of our lives. Isa quit her tenured job at Birkbeck and we sold our flat. Words had led to action as maybe they always should.

Mud and ACAB

Many words are walked in the world, many worlds are made. Many worlds make us. There are words and worlds that are lies and injustices. There are words and worlds that are truthful and true. In the world of the powerful there is

only room for the big and their helpers. In the world we want everybody fits. The world we want is a world in which many worlds fit.

Fourth Declaration of the Lacandon jungle, the Zapatista Army of National Liberation, January 1, 1996

Chris leans forward, her long fingers play with the dial of the car radio "I'm trying to find 107.7 FM" . . . a burst of Classical music, a fragment of cheesy pop. "Ah! Here we go! I think I've got it!" The plastic pitch of a corporate jingle pierces the speakers: "Radio Vinci Autoroute: This is the weather forecast for the west central region . . . happy driving to you all. Traffic news next." Chris smiles.

The narrow winding road is lined with thick hedgerows. Out of the darkness the ghostly outline of an owl cuts across our headlights. We dip down into a wooded valley, the radio signal starts to splinter. The woman's voice fractures into static; words tune in and out, a crackle and then another kind of sound weaves itself into the airwaves. We rise out of the wood onto a plateau, the rogue signal gets clearer, for a while two disturbingly different voices scramble together—the manicured sounds of Radio Vinci wrestles with something much more alive, raw and fleshy.

"The cops have left the Zone for the night . . . Good riddance . . . Yeah! Keep it up everyone!" There is a moment of silence. "This is Radio Klaxon . . . Klac Klac Klac!" Her emotion radiates. "It's nine thirty-five." She laughs and puts a record on, passionate Flamenco guitar

45

pumps into the car. We have entered la zad (Zone
A Défendre—Zone to defend), a kind of rural
Occupy on the eastern edge of Brittany, half an
hour's drive from the city of Nantes.

We blogged[28] these words on the night of
October 16, 2012, fingers still shaking with
adrenaline, clothes stinking of tear gas. Despite
the dampness seeping into our feet, we felt elated.
The gendarmerie's *Operation Caesar* had just begun,
hundreds of us had played cat and mouse all day
with battalions of riot police, running through the
sticky mud of these wetlands, trying to stop the
evictions paving the way for the airport.

Radio Klaxon was the zad's own pirate station,
squatting the airwaves of the multinational
corporation Vinci's banal motorway radio. Vinci
was granted the exclusive right to build and
manage the airport, like they do much of the
toll motorways in France. 'Their' land was being
squatted to block the construction . . . so why not
their airwaves? This was one of many creative
forms of resistance bringing this pocket of land
to national and global attention, and making this
place a mythical territory, "lost to the republic"
according to some French politicians. It is a
place that 24-hour French tabloid news channel
BFMTV would unexpectedly describe, years later,
as "a utopia that might be being realized."

We'd just moved to France and were living
about one hour and a half away. We will never
forget arriving in the *Rohanne* forest for the first
time amid *Operation Caesar,* the lines of robocops,
the choking teargas, the machines pulling down
the tree houses. There are folk high in the trees

to protect them, retired villagers singing revolutionary songs to the gendarmes, paint bombs flying, naked protesters demonstrating their vulnerability in the face of the heavily armored robocops, people sitting on the roof of threatened farmhouses, refusing to move.

At night, when the police leave (they never spend the night on the bocage but return every morning) barricades appear like mushrooms after a downpour. Each one is a work of insurrectionary sculpture: One, made from dozens of silver bicycle wheels, caught like flies in a web of steel rope stretched between trees. Another has a huge hole dug in the road in front of it and is the cause of conflict among the comrades because trees are cut down to make it. Another is a self-referential joke, made entirely of *sitex* panels normally placed on doors and windows of empty houses to discourage squatting. Farmers have moved huge hay rounds and blue IKEA bags filled with stones are set beside them with cans of petrol ready to set the barricade alight. Radiating from the strategic *Saulce* crossroads at the center of the zone, there are over 20 barricades. Within one is a kitchen with mobile pizza oven made out of an oil drum. One of the 'historical' farmers (a term for the peasants living on the zone who refuse to be expropriated by the state) turned his barn, *La Vacherit* (a play on words meaning both laughing cow and dirty trick), into a safe zone where mountains of dry socks have been brought by local villagers, along with piles of chocolate, rubber boots, warm food, and portable radio batteries. Listening to *Radio Klaxon* in the fields is a lifeline: it beams out motivating

music and gives precise updates on the position and movement of the cops.

The main highways around the zad are blocked by farmers' tractors.

We spend the rest of the day sinking our arms into the cold, wet mud, grabbing handfuls to throw at the gendarmes. It is a joyful and efficient tactic. The thousands of robocops shipped in from across France for the operation find it hard to navigate through the bocage. And when showers of well-aimed sludge rain onto their visors they become more disorientated. Several of their destruction machines have already succumbed to the earth's wet grip. "We live here and we will stay here! ACAB!" screams Camille, throwing another handful of mud, grey eyes piercing through the teargas. Her sleeve lifts up to reveal a tattoo: *We are not fighting for nature. We are nature defending itself.*

Camille whispers a new technique. "If you aim the mud at the top of the knees, the ooze slides down between the leg and the body armor and the robocop can't bend their knee anymore. With a bit of luck, they soon topple over like Playmobil characters!" We keep advancing, a bunch of cops start to pull out of the forest. Our muscles are tired, but our veins flow with that deep joy and profound sense of aliveness that emerges when disobedient bodies are working together. Our accomplices that day are human and mud: that dark humid complex holding billions of bacteria, fungi, viruses, actinomycetes, algae, protozoa, and nematodes, recycling the flesh of plants and animals, turning decay into food, transforming death into the gift of life.

That night's last blog sentence read: "The word humble (like the word human) has its roots in humus, it means to literally return to earth. Perhaps the future will be built by heroic acts of humility rather than arrogant temples to growth. Perhaps civilization's dream to suck this zone dry with its concrete and tarmac, steel and plastic will be vanquished by wetness."

Insurrectionary Inhabiting

East of the forest there is another front, and we spend much of the start of *Operation Caesar* there, at a big cabin and collective vegetable plot called *Le Sabot* (The Clog). It is so named to recall the French root of the word *sabotage*, which entered common speech in memory of workers who threw their wooden clogs into the machinery to rebel against the deskilling and speeding up of their work at the dawn of capitalism. *Le Sabot* is located on two acres of fallow land squatted in May 2011 by 1,000 people, many carrying spades and pitchforks, under the banner of *Reclaim the Fields*, a nod to the 90s rave and urban commoning direct action movement *Reclaim the Streets*. A horizontally organized European collective, bringing together young peasants, landless and prospective peasants, and anyone wanting to take back control over food production, *Reclaim the Fields* refuse to separate the practices of agriculture from a critique of capitalism and its forms of life.

It's early, we are waiting for the police to return. A silhouette appears out of the dawn, masked up and carrying a freshly painted sign. They climb

49

over the barricade protecting *The Sabot* and attach the sign to a tree, ready for the gendarmes, who will soon turn the morning mist into clouds of poisonous tear gas. It reads: *Zone of Struggle: Here the people command and the government obeys*.

The phrase is inspired by the Zapatistas, the masked Indigenous rebels, the people "the color of the earth" whose 1994 armed insurrection in the Chiapas highlands reinvented the radical political imagination, placing dignity and a recognition of difference at the heart of rebellion. A quarter of a century later, their autonomous community-run municipalities, free from the influence of the Mexican state and global capital, remain a rare example of long-term political sustainability.

Much to the joy of people on the zad, messages of solidarity have been arriving from Chiapas.

Zapatismo represents a bold departure from worn-out models of top-down Marxist visions of 'progress,' far from their 'inevitable' authoritarian transition via a strong centralized state. An avant-garde of intellectuals sadly continues to spread this tired homogenizing ideology. Instead, Zapatista communities organize themselves according to a heterogeneous, bottom-up Mayan cosmopolitics, but also draw inspiration from a plurality of traditions. Their multilingual communities are comprised of Mayan people that have been resisting annihilation and forced migrations since the European invasions began 500 years ago. All have lived through various ends of their worlds, and thus perhaps their example can teach us how to live together after *this* end of the world. Rather than seeking to 'take power', the Zapatistas

promised to erode it in order to create space for democratic self-organization; they refused to offer a universal recipe for revolution and strive to be a "bridge to cross from one side to the other", a bridge toward self-determination and secession from the state and capitalism. "There is only a desire: to build a better world, that is, a new world," reads one of their mythico-poetic communiques.

The Zapatistas taught us that we can have a future-facing radical politics rooted in folklore and tradition, bound into the earth and emanating from a local territory, yet internationalist in its outlook. They demonstrated a politics of the earth without chauvinism or the xenophobic myths of blood and soil fascism. They developed a non-binary fractal politics, where past and future fed each other, and the individual and collective could not be disentangled: "we are you," they said.

Key was their bypassing the barren binary of local and global. Their 'local' struggle inspired a 'global' revolt of the alter-globalization movements of the early 2000s. They've survived because without this international visibility and solidarity, their insurrection would have ended in repression and bloodshed. Their genius was to extract themselves from a national centralized metropolitan framework, which would relegate them to being merely a 'local struggle' and to link up with an archipelago of radical forces.

As the French collective, *The Invisible Committee* writes:

We risk losing everything if we invoke the
local as against the global. The local is not
the reassuring alternative to globalization, but
its universal product. Before the world was
globalized, the place I inhabit was simply my
familiar territory—I didn't think of it as 'local.'
Local is just the underside of global, its residue,
its secretion, and not something capable of
shattering it. Nothing was local before one could
be pulled away from it at any time, for profes-
sional or medical reasons, or for vacation.[29]

The scientific revolution of the seventeenth
century cemented the dualism at the core of met-
ropolitan thinking. We had "to make ourselves,
as it were, the masters and possessors of nature,"
wrote Descartes' whose dictum, "I think therefore
I am," became the template for all mind-body
binaries. But that famous phrase was followed
by a lesser known one: "a being needs no place
to exist." This revolution's dream was to fool
humans (at least the male, European elites) into
imagining themselves independent from the rest
of nature, to separate nature from society, so we
could understand, dissect, and therefore control
it. It gave things, objects, entities much more
value than relationships, and developed a logic of
either/or rather than both/and. Born as financial
capitalism emerged in Europe, this poisonous
binary logic continues to be spread everywhere by
financial market flows, transport infrastructures,
and communication technologies, all ignoring
place as a basic constituent of human existence,
and putting 'just in time' speed first.

Much contemporary Western radical politics, with its copy and paste ideologies, debates, and discourses bathed in abstraction, has been molded by this vision. Ideas are more important than place and humans are the only agents of history. The Zapatistas remind us to bring our political cultures back down to the scale of earth, to a particular, situated territory. A place that, like all places, is never neutral and always alive, loaded with stories, feelings, and other beings. A place that, like all places, is uniquely affected by, and affects everything that passes through, and settles on it.

Since the financial crash of 2008, space-based movements—emblematized in Gezi Park, Tahrir Square, Occupy encampments, and movements associated with the *indignados*, including Spain's 15M—have radicalized and galvanized multitudes. Though they inspired more long-term neighborhood projects, these Temporary Autonomous Zones were all dismantled through police repression. In contrast to these largely urban protest occupations, the zad had something else in its essence, something more resilient. This something tried to take the shape of an insurgent pluriverse, or what the Zapatistas described as "a world where many worlds fit," that could be built in the here and now with hands and soil, architecture and vegetables, tractors and assemblies, all kept together by a shared enemy. "The naming of the intolerable is itself hope," wrote John Berger, and the intolerable in the bocage was the airport.

The barricades have fallen, tear gas has engulfed *Le Sabot* now. Marsios and Thea climb

onto the roof of the cabin, holding a bright pink, green, and black banner *Zone d'Autonomie Definitive*: (Permanent Autonomous Zone) it reads, they smile cheekily and turn it around to reveal *Zone Anti-Depressive* (Anti-Depressive Zone). "If there is any hope for the world at all," Arundhati Roy says, "it does not live in climate-change conference rooms or in cities with tall buildings. It lives low down on the ground, with its arms around the people who go to battle every day to protect their forests, their mountains and their rivers because they know that the forests, the mountains and the rivers protect them."[30]

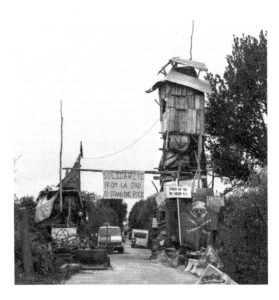

One of the cabins on the infamous road of the chicanes, Philippe Graton, 2016.

Building in the Ruins

It's like living in the playground you always dreamed of as a child.

Camille, inhabitant of the zad.

The name zad is a hack of the official planning term *Zone d'Aménagement Différé*, which means an area of land dedicated to a future development project. The first mention of the airport was in 1967, and resistance began to brew in 1973 with small demonstrations by local peasants at harvest time.

Some of them had been moved by listening to the sound of planes taking off from the new Roissy Airport near Paris, recorded and played on reel to reel by peasants who did not want to see the food producing land destroyed. These storytelling evenings around farms' fireplaces brought the sensory reality home to the bocage inhabitants. Over a dozen families refused to let their farms be expropriated.

There was already a rich soil of rebellion in the region. The 70s had seen a powerful farmers-workers movement emerge, with the coming together of industrial workers and farmers around the May 1968 riots and strikes that pushed the state to the brink. Providing food for striking workers in the region's factories, the farmers-workers movement left a legacy of radicalization for many of this territory's peasants. On top of this, the 80s had seen resistance prevent the construction of several nuclear power stations in the region.

The airport project took many shapes over the decades. Before the oil crisis of the early 1970s, it

was imagined as a hub for air freight, a "Rotterdam of the West." Later it was sold as home base for France's fleet of supersonic Concorde passenger jets. The latest 'green' version appeared on the table in 2000. In response, the mostly local citizens' association, ACIPA,[31] was created to spread information and mount legal challenges. Then, in 2009, a new ingredient was added to the struggle when the bocage hosted France's first climate camp. *Les Habitants qui Résistent* (Inhabitants who Resist), a collective founded by families refusing to be expropriated and fed up with ACIPA's fear of direct creative action, read an open letter to the mostly urban anticapitalist campers. Farms and houses were being sold to the airport builders, inhabitants were being pushed off the land by the expropriations; if this land became another rural desert, the airport could not be resisted. The letter invited people to squat the land and move into empty buildings and thus to put their everyday lives in the way of the project. "To defend a territory, you have to inhabit it" the collective wrote.

When the climate camp folded up its tents and marquees, a couple dozen people stayed to build huts, squat abandoned farms, plant gardens, and construct bakeries. They slowly made links with resisting peasant farmers and villagers. The *Zone A Défendre* came to be, resistance ripened into one against the airport *and* its world.

When, some three years later, October 2012's *Operation Caesar* brought thousands of police to the zone, they were only empowered to evict the squatters, not the farmers and the families refusing to be expropriated. This was thanks to a month-

long hunger strike of farmers and citizens earlier that spring, which forced the government to back down on evicting them until all legal proceedings were exhausted. But despite the movement's heroic resistance, 13 cabins and farmhouses were destroyed within days. Every stone of the farmhouse ruins was removed, not just because the stones could be thrown at the cops, but because the state must erase all traces of rebellion.

Operation Caesar demonstrated that an extraordinary diversity of complementary tactics can make a movement resilient to government attacks. Always complex to navigate, it was to become a deeply engrained lesson for years to come. Some pursued non-violent direct action while others threw Molotov cocktails. On the ground it confused the cops, one minute they faced old age pensioners singing songs, the next a burning barricade. In the media battle of the story, the state could not capture us in their classic trap, they could not divide us with the 'good' vs 'bad' protester stereotypes. Despite inevitable tensions, the movement kept itself together, not letting different approaches divide it.

Images of the rural revolt, with tear gas poisoning vegetable plots and youth being pulled out of trees, went viral. Support rose across the country. Over 200 local action committees formed, from Parisian neighborhoods to far flung towns. As the bocage was invaded, over 100 actions took place across France, often animated by the catchy sung slogan, *Vinci dégage, resistance et sabotage* (Vinci get out, resistance and sabotage). Candle-lit vigils were held in Christmas markets; the offices of

the ruling Socialist Party's premises were spray painted; local town halls were festively occupied; Vinci building sites throughout the country had their machines sabotaged.

But there was one event that turned everything around. A movement call had gone out a year prior: if there was an eviction, people would return to reoccupy and rebuild exactly a month later. We still get goose bumps remembering that November 17, 2012 when, arriving at the meeting point in the village of Notre-Dame-des-Landes, we saw 400 tractors winding their way down country lanes pulling trailers piled high with buildings materials, people joyfully hanging from the mountains of pallets like floats of a rebel carnival, and the police suddenly nowhere to be seen.

Beyond all expectations, 40,000 people from throughout France had turned up, some had even bought flat packed cabins from more than 900km away. Once on the zad, thousands of us lined up either side of newly cut tracks, shoulder to shoulder, forming human chains that stretched over half a kilometer from the trailers to the building site in the middle of a chestnut grove. Piece by piece, hand by hand, strangers passed planks, drainpipes, furniture, pots and pans, logs, bathtubs, stoves. As the sun set, someone brought a drum kit and amps into the middle of the coppice and experimental jazz accompanied the hammering that went on late into the night. This was theater as it should be, totally epic, outdoors, and embodying happiness. This was an art of life, not an exclusive show shutting people up in a dark cavern, in silence and inaction, but a festival of

disobedience. There were no binaries of spectator and actor, everyone was part of the spectacle, everyone was an actor.

By the end of the weekend, a hamlet had emerged in the clearing with collective kitchen, blacksmiths workshops to make slingshots, five dormitories, a tavern, first aid post, meeting rooms and a bathroom with its little added luxury in the sea of mud: a hot tub. Called *la Chat-teigne* (a play on words of chestnut becoming angry cat!) it would house people arriving to defend the zone.

Four days later in the middle of the night, the police crept into the grove, smashed the windows of one of the new dormitories, threw teargas inside and began clearing the hamlet, making one of their greatest strategic mistakes: no one was going to let them take this place that had been built by tens of thousands of hands. Fighting erupted in the forest around. Isa and I joined the bodies surging toward the police lines. I felt the wind of a rubber bullet whistle past my head, so many eyes have been ripped out by these weapons. Our ears rang with the sharp crack of stun grenades, each emitting 155 decibels of sound, 40dB louder than a plane taking off, enough to rip an eardrum apart. Our skin burned from tear gas, hurting so much that we fantasized about lying down and burying our faces in the cold wet leaves on the floor of the forest. But this would have been suicide, we had to keep mobile, appearing and disappearing, frontline to forest and back again.

As the fighting peaked, local doctors wrote an open letter saying that what they were witnessing were "war wounds" from the police's weaponry

and that they feared someone would die. A few days later the attack stopped—rumors ran that the recently elected 'Socialist' president Hollande was not prepared to politically weather the scandal a protester's death would awaken. As the troops retreated, the forest reverberated with wolf howls erupting from the mouths of tired wetland defenders. *COPAIN*, a new regional network of agricultural organizations against the airport, surrounded *la Chat-teigne* with 50 tractors chained together to defend this symbol of resurrection, whose construction was to change the course of the movement and transform everyone who attended.

Bodies don't forget days like that.

While most of the police had left, the prefecture (local interior ministry) signed a decree to stop building materials and tools from coming onto the zone. Police set up roadblocks to check ID papers and search vehicles. The final check point remained until spring 2013 when the last small group of police left, and an action entitled *Sème Ta Zad* (sow your zad), *Occupy, cultivate, resist*, seeded twelve new agricultural projects on the zone.

Then something extraordinary happened: the police didn't return—for six years! The state had gambled on that old story that rulers need to tell themselves that a people without strong governors, weaponized police, and prisons, will inevitably destroy themselves and 'fall' into chaos.

In their imagination, this would be the zad's inevitable fate. Those six years were no Shangri-La.

There were recurrent conflicts and crises. But through thick and thin, the zad existed as an

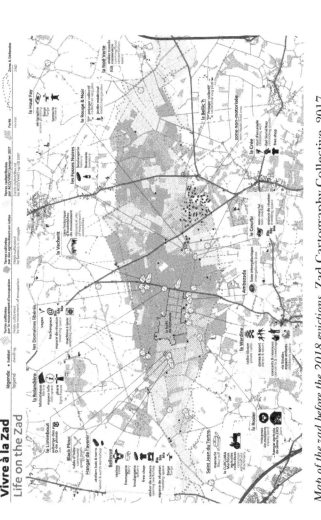

Map of the zad before the 2018 evictions, Zad Cartography Collective, 2017.

autonomous zone with no police or politicians, judges or elected officials setting foot within it. Everyday life, with its mess and complexities, had to be self-organized, collectively and as horizontally as possible, through affinity groups, working collectives and assemblies, while continuing to organize a movement against the airport.

From the wet winter of 2012 to the vengeful spring of 2018, Europe's largest and beautifully imperfect canvas of commoning flourished. About 80 different collective living spaces were established and over 350 people shared life together. A flour mill and tractor repair workshop were set up, as well as a brewery and banqueting hall, medicinal herb gardens and rap studio, dairy and tannery, screen printing and textile workshop, orchards and vegetable plots, buckwheat fields and a weekly newspaper, a blacksmith's forge, and a hacker space. The zad became a living experiment in taking back control of everyday life, despite the double headed monster of state and capitalism. Without planning laws, creativity could be unleashed, habitats made from the land's sculpted clay emerged, there was a tree house shaped like a giant bird box, wooden towers built on a road, a floating cabin for making love, and huts made from the refuse of the world. The idea was not to search for self-sufficiency, but to build self-managed autonomy.

A Discipline of Attention

For us both, the zad embodied the DNA of successful revolutionary processes, made up of

two entwined strands: the yes and the no, protest and proposition, resistance and creation, fighting and building.

If we only create so called 'alternatives' and don't manage to successfully block, sabotage and dismantle the toxic industries, and the machines of capitalism that are wrecking communities, the climate and our biospehere, our wind farms, urban gardens, eco villages, etc will be overwhelmed by spreading deserts or floodwaters. Conversely, if our movements only say 'no' they are less desirable and inviting and generate activist burnout. Participants go home having never experienced the pleasure and love for the world they are fighting for. But there is another risk: if it's all 'yes', and if new forms of living are disconnected from the struggle against capitalism and forget who the enemy is (as is all too often the case in transition towns or schemes for a Green New Deal), they are easily folded into the existing system. Indeed, we need to take a grim warning from the way that California's utopian hippy communes paved the ideological paths for the individualist culture of Silicon Valley that brought us today's surveillance capitalism.[32] Utopias without resistance become laboratories for the new spirit of capitalism. Life on earth cannot afford a new form of capitalism either in green or in any other color. When the yes and the no come apart, we lose what gives life to rebellion, and rebellion to life.

Never wanting the police to enter the zone again, the zad had to deal with its own conflicts.

Like any community, there were disagreements and conflicts over norms, land usage and behavior.

There were also mental health crises and instances of sexual violence, homophobia, and physical threats. So, the zad had to design and set up a sort system of communal justice from scratch, which avoided power being concentrated. For instance, a group of twelve inhabitants randomly drawn from a pool of volunteers was for a while dedicated to mediating conflicts. Members of the group were 'on call' for one month, half of them rotating every other week so as to ensure continuity in dealing with cases. It aimed to de-specialize the task of dealing with conflicts, turning it into a collective responsibility rather than a problem to delegate to 'experts' (such as police, social workers, or psychologists). However, the overall mounting pressure exercised by the state's threats of evictions exhausted volunteers and the initiative petered out. All this social experimentation around new forms of life is a messy and difficult process, but compelling in its intensity. Few of us experience an everyday life free from rules imposed by others, and the zad had to re-invent and rediscover forms of life and community constantly. Some worked better than others, many were tried and lots abandoned, people fought and fell out, arrived and left, but somehow the whole organism was resilient.

One key was improvisation, that is the ability to respond artfully to a given situation by opening up to the possibility that the situation affords, rather than imposing a ready-made cut and paste solution or ideology to it. "A key to survival is improvisation," writes performance studies scholar Barbara Kirshenblatt-Gimblett. It is

there, where we should "start thinking about an aesthetics of everyday life."[33] When you no longer outsource problems and needs, everyday life goes from relying on coded and unthought 'automatic' behavior that only facilitates the extractive world, to being a generative process of tact and techniques. Folded back into life, art becomes a process of attending to the specific details of living, it becomes about caring and nourishing the relationships that make up the everyday.

We need "a technique of life, an art of living. We have to create ourselves as a work of art," claimed philosopher-activist Michel Foucault. "Rather than something specialized or done by experts, couldn't everyone's life become a work of art?" he asked. "Why should the lamp or the house be an art object, but not our life?"[34] Of course this question had been asked many times before Foucault, from Dada to Surrealists, through Bauhaus to the Constructivists. Even at the dawn of the invention of Art-as-we-know-it in the mid 1700s, Mary Wollstonecraft, early advocate of women's rights and mother of Mary Shelley, wrote a forceful critique of the new moves toward contemplative disinterested aesthetics that separated taste from the particular interests in life and everyday sensual pleasures.[35] Where, she asked, is this infallible sensitivity, this taste reserved for the refined ruling class, when colonial women who order their enslaved Africans flogged, can then "exercise their tender feelings by the perusal of the last imported novel." The same was true for the elite's estates, which were seen as sublime picturesque '*objects* for the eye' and yet hid from the

imagination the 'distress of poverty,' the evicted commoners and the hours of hard workers' labor gone into their production. For Wollstonecraft, a landscape could only be truly beautiful if its form was a reflection of justice and happiness. She imagined a countryside dotted with small farms populated by joyful land workers. We must turn "our eyes from ideal regions of taste and elegance" she declared "to give the earth...all the beauty it is capable of receiving." If her ideas had triumphed, the invention of Art-as-we-know-it might have been derailed. Art might never have become a tool for corporations to artwash their toxic behavior with, via sponsoring cultural institutions. Art might never have been turned into the pathetic immaterial asset of financial speculation. Beauty might have become inseparable from justice and aesthetics totally twisted into ethics.

One autumn night in 2013 not long after we had moved to France, to set up the land based collective la r.O.n.c.e[30] that would become the stepping stone to us moving to the zad three years later, I had an embodied realization. I had just lit the stove after a tiring day chopping and piling up wood for next winter's heating, my arms ached. I had never ever had a connection with what warmed my body in the metropolis, except a sense of eco-guilt when I switched on the gas boiler. Now every time I put a log into the fire, I could not forget that it had once been a living being, with whom I shared the land. The disconnecting logic of the metropolis began to wear off, Isa and I began to understand what an art of living, a discipline of attention might feel like. We began to sense what

it meant to inhabit our territories as much as our bodies, to feel the pleasure of sensing the texture and stories of things and beings that make up our entangled lives. This deep sensibility to doing and being is in itself a form of caregiving. Attention is giving yourself to an object or an activity, be it making bread or making love, cutting someone's hair or trimming a hedgerow. It requires presence, here and now. Being present means working with what is at hand rather than waiting for some moment of perfection, it means letting go of fixed ideologies in favor of sensing situations. Such presence means that we begin to know where our food comes from, where the nearest spring gushes out, which plants heal headaches, what species of mushroom spreads beneath our feet, how to build a house, how to share life. It senses the weather changing on our skin, it feels the tidal pull of the full moon on our bloodstream. A deep presence means that we notice when springtime comes late, when the local songbirds fall silent, it means that we cannot passively watch the rise of authoritarian governments. As Allan Kaprow so wisely said: "Art is simply paying attention."[37]

It did not take long for the state and its media mouthpieces to begin to call the zad the "outlaw zone," while they pursued their legal process to get the go ahead to bring in the bulldozers. Many of the court cases fought were appeals made on behalf of species on the zone, such as the red listed endangered *Southwestern water vole*. In January 2013, in the wake of *Operation Caesar*, a four-year in-depth species inventory by a network of scientists and local citizens, the *Naturalistes en Lutte*

(Naturalists in Struggle), began. It aimed to show the glaring inadequacies of the piecemeal survey done by Biotope, the company outsourced by Vinci to carry out the ecological audit. As a result, the bocage is one of the areas in Europe with the most detailed cartography of its biodiversity.

Love and Forgetting

One damp night in 2015, we realized that we had fallen in love with this place so much that we were prepared to live here and defend it with our lives.

We were visiting our friend Marsios, drifting on that beautiful edge between the waking world and the sleeping one and listening to a sound we had never heard before. The darkness was vibrating with a colossal chorus of frogs croaking in the marshes. There were thousands of them, serenading love to one another. It was beautiful, yet it saddened me. It reminded me of my mum and made me miss her terribly. The frogs sounded so much like the sound of her breathing, that croaking crackle of a death rattle, that I listened to 24 hours a day, as I held her and watched her slip away from life, the previous winter. She had suffered from Alzheimer's for years and by the time she left this world, there was little left of her body and even less of her memories. Recent scientific discoveries point toward the link between this horrible disease and the decline of biodiversity in people's guts.[38] Could it have been that her brain atrophied because her gut, that dynamic ecosystem that should have been home to 1000 species of bacteria, but had had its diversity

destroyed by being bombarded with the synthetic chemicals that are now in our food, air, and water? Her memory was stolen and, with it, her stories. All the thousands of people and places that had produced that unique her, all those relationships with worlds were erased by the disease.

Alzheimer's left her uprooted, drifting without anchors to the past, or hope for the future. She no longer knew where she was or who she was. Her disease somehow seemed a mirror image of the ravages of capitalism, this logic that has made us forget what life is. Like capitalism, the disease breaks our ties to each other and places, pushes us to be atomized, separate individuals floating above everything. In this perpetual process of uprooting, capitalism forces us to forget our stories, especially those of our collective ancestors—human and more than human—those that give us strength against the hopelessness, and remind us that rebellion and resistance work.

The zad fiercely fought against forgetting, and we wanted to be part of that adventure. We would move there. Just as the swallows returned in the spring of 2016, an affinity group of half a dozen of us put all our belongings into storage and packed up rucksacks of essentials. We converged on *La Rolandière*, an old farmhouse that had been left by its resistant inhabitants, right in the heart of the zad, to squat it and turn it into a welcome center. The President of the region had just launched a petition to demand the eviction of the zad, asserting that it was as dangerous to visit the zad as the ISIS enclave of Mosul in Iraq, telling journalists that "if the airport is not built, the zad

will become the rear base for all the guerrillas against projects of this type in France." We wanted to demonstrate how ludicrous his fantasy was, and respond with weapons of conviviality, opening and reaching out to people. And we hoped to prove him right on the second statement, by contributing to develop a material basis, providing food and tools, knowledge and hope, care and support for rebellions. Something much more useful, more graceful in this epoch, than another airport. Something that brings us to the roots of the word remember, literally to be *mindful again*.

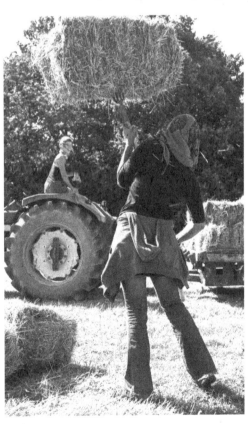

Harvest time on the zad, Philippe Graton, 2016.

VAG
ABO
NDS

Part III: Rooting

Offensive Defense

That's how I resist, by keeping working till the
police arrive.
Whether we like it or not, we have become
more than ourselves.

> Marcel, farmer living and
> working on the zad.

While the swallows repaired their nests with
mud and spit in the old concrete cow manger
of *la Rolandière*, our new collective, with dozens
of helping visitors, began transforming it into a
welcome space for people arriving on the zone for
the first time. On the newly rendered mud and
straw back wall we hung a giant hand-painted
map of the zone. It was yet another act of mate-
rialized hope on the bocage: so much energy and
work put into something, yet with the knowledge
that all of it could be evicted and destroyed at
any time. We kept recalling the words of Arnau,
a friend from Can Mas Deu, a squatted former
leper colony on the hills overlooking Barcelona:
"That's the beauty of living in a squat, you settle
as if you were going to spend your entire life there,
you fight to stay, but you also know that it can all

end tomorrow. It is good preparation for life's own impermanence."[39]

As 2016 began, all legal procedures countering the airport project had run their course and construction was given the green light. Manuel Valls, ex-Interior Minister who had to pull back his troops in 2012, was now Prime Minister. "The government will not give in to intimidations by a minority of individuals, the laws of the republic will be applied to Notre-Dame-des-Landes like everywhere else" he asserted: the construction would begin as soon as everyone was evicted. This time even the 'historic farmers' had eviction orders served. For every day that they remained they would be fined up to €1,000 and their property would be seized. They had been made into squatters in their own homes. When the bailiff brought eviction papers to Marcel and Sylvie's farm, he asked where they would resettle. "We are already settled here," retorted Sylvie "we won't go, we have never looked for a farm elsewhere."

No one knew when the evictions would begin, and it was clear that Valls was not going to risk a second defeat. This time he would come in harder. Two thirds of the country's gendarmes were mobilized to take part. There was a tight schedule: if construction had not begun by January 2018, the compulsory purchase orders and planning laws would expire. To make matters more complicated for them, in November 2014, the police had killed a young botanist-activist on another zad (the term is now used throughout the country for any land based resistance to the building of toxic infrastructure and has even entered the French

dictionary) that had been established to block a dam for intensive agriculture.

Somewhere in the metropolis' offices, bureaucrats were pouring over detailed maps and plans, laying out logistics to start the building site, imagining how and where the first scoop of the bulldozer would happen. After 40 years of struggle against the airport project, it would be a charged moment for all sides. It was obvious that all the machinery would have a huge police escort, 24/7. Construction would begin with a motorway exchange, for the new four-lane road to enable the machines to access the site and eventually serve the airport.

To the imminent threat, the movement responded with a strategy that was a leitmotif of the struggle: always stay one step ahead of the enemy; don't wait to be attacked, go on the offensive. When I first got involved in direct action with the UK anti-roads movement, it was a movement against the building of motorways and ring roads, part of a giant infrastructure plan for what the conservatives called "the great car economy." I had been inspired by what I coined "the art of necessity,"[40] the ingenuity that the anti-road activists put into forms of defense, such as the aerial networks of hobbit-like treehouse villages and the complex tunnel networks dug deep into the earth under threatened forests. Most of us involved at the time thought that the evictions were inevitable, and so all the energy was put into making them as difficult and lengthy, and therefore costly, as possible.

In the anti-roads movement, there was a twin strategy of what we called 'fluffy' disobedience in the daytime, blocking the bulldozers often with local residents support, and at night secretly sabotaging the machines, called "pixieing" after mischievous fairies. It worked: despite losing many key battles, the war was won, and 600 planned roads were canceled.

But the movement against the airport was doing something very different: it was putting most of its energy into ensuring that the evictions would *never* come. The movement's first offensive began early on a cold January 9. The words "first warning" were spray-painted onto the central guardrail of Nantes' ring road, as 1,000 bikes, 450 tractors, and 20,000 people replaced the traffic and blocked western access to the city. Flowing onto the monumental Cheviré bridge, arching high across the Loire River and with an extraordinary view of the sprawling city below, we set up long banqueting tables and were served by mobile kitchens. The demand was that the president cancel the eviction procedures. Their response that night was water cannons to clear the bridge.

Then, on February 27, the movement issued its second warning. It was simply a call for people to converge onto the land beside the existing nearby motorway where the first phase of the construction would begin. 60,000 rebel bodies turned up to help burn an image into the imagination of the airport builders of what their first day of work might look like! A street party filled the motorway, we danced to bands playing from flatbed trucks,

kilometers of tarmac were painted, and the nearby petrol station was given a colorful makeover.

Everyday Magic

In the first blog we wrote about the zad in 2012, we called it "a kind of rural Occupy." But by the time we moved here in 2016, the movement against the airport was consciously transforming the temporary 'protest camp' imaginary that was often projected onto it, by creating a sense of common belief that the airport would never happen. "You have to act as if it were possible to radically transform the world. And you have to do it all the time," Angela Davis famously said,[41] invoking that magical formula, "act as if."

A popular conception of magic, from Harry Potter to World of Warcraft, is that it involves a supernatural force that can only be directed by gifted people twirling magic wands to levitate bodies or shoot fireballs. But magic is far from this Newtonian mechanical conception. The best magic, and the same is true for art and activism, assumes that attention is an organizing principle of reality, it is an instrument of imagination. And as our friend and teacher Starhawk noted, this craft should never be monopolized by experts: "Everyone can do the life-changing, world-renewing work of magic, the art of changing consciousness at will."[42] Being able to use the instrument of magic is simply recognizing and training the power of imagination, to create reality, rather than escape it.

It's all about raising up energy and focusing it toward a goal with the intention to create change.

Given the urgency of the epoch, the best way of doing this is not alone with your crystals, or in an Instagram coven, it is weaving yourself into creative movements of struggle, which are the most powerful forms of everyday magic.

When we break the 'tyranny of consensus reality,' it liberates us from what philosopher William James called the "habits of thought," the limits that we think are natural but are in fact constructed and so can be overlaid with new habits from which new behaviors emerge. Reality is held together by the most successful stories we tell about it and therefore can be transformed, via differing stories and myths, which shift attention. "Politics (. . .)" wrote David Graeber, "is the art of persuasion; the political is that dimension of social life in which things really do become true if enough people believe them."[43] While the alt-right and authoritarian regimes everywhere know that it is more effective to conjure emotion by galvanizing myths than telling people the sober 'truth,' many social and ecological justice movements continue to hang onto facts and figures to 'convince' people. But as Kasper Opstrup writes, "it is no longer about whether a proposal is true or not, but about how effective it is to make something happen."[44]

Many in the movement against the airport did not fear the magical formula of fabulation, "act as if". The performative art of invoking desirable fictions was perfected when the movement began casting the immutable collective belief: there would *never* be an airport. There were many ways

this belief was formulated, but two key tactics were a declaration of a six-point vision for the future of the zad, and the disobedient construction of substantial buildings, envisioned as a longterm mainstay of community.

A vision for the zone after the cancellation of the airport was formalized in 2015 following a long period of discussion within the movement. It came in the punchy six-point declaration of how the bocage and the life that inhabits it would organize in a post-airport future. Key was that those who had cared for and saved the bocage would be able to stay, thus keeping a diversity of ways of living and farming, organized in an assembly where those living on the land would gather to decide the modalities of its use. Entitled "Because there will never be an airport at Notre-Dame-des-Landes," the 6 points were distributed as posters and flyers, and were repeated through media and at rallies. They became powerful imaginative anchors for collectively believing in a future other than the airport.

Added to hacking the imagination was the idea to create material structures that suggested that we and our descendants were here to stay for the long term, the zad was not a Temporary Autonomous Zone. New buildings that materially embodied longevity emerged. In the summer of 2016, 80 carpenters held their annual gathering here in solidarity with the struggle. Using tradi-tional techniques, they turned ancient oaks into the frames for a massive barn, to be raised in the autumn: what would become the *Barn of the Future*.

Cue ominous music: fade-in traveling shot through a car windscreen. It winds along a long straight road partly reclaimed by bushes and blackberries. The way is punctuated by makeshift chicanes, Mad Max-esque car carcasses planted with gardens, wooden towers and wonderfully wonky cabins. A sign at the entrance reads "End of the asylum, beginning of the zad." Cue grave voice over: "To slip inside the zad of Notre-Dame-des-Landes is entering another world." This was the classic opening shot of so many news items and documentaries, aiming to make this place seem apart from 'normal' society, somewhere separate, other, and strange. The less liberal media machines wove stories about us being armed with rocket launchers and razored *pétanque* balls and leaving aborted children in the ditches.

There is a dangerous tendency that 'radical' movements can become seduced by the very imagery of threat and danger projected onto them by their enemies, reveling in their infamy in ways that are usually profoundly alienating to most people who might otherwise be sympathetic. Instead of taking the risk of engaging broadly and "staying with the trouble,"[45] as Donna Harraway would say, multiplying differences and reaching out toward otherness, they obsess over keeping their rebellious identity frozen. This is not about becoming a conflict fearing liberal, prepared to love and work with anyone. As Donna Harraway wrote to us once: "I am and always have been for some worlds and not others. If ever there

was a time for life-affirming anti-capitalism, it is NOW."[46] Movements need to take firm stands that will not please all, to set clear boundaries and to risk ending alliances over matters of principle. It is a matter of learning to listen, share, shapeshift, and evolve, yet avoid capture or cooptation.

All bodies can be regarded as 'super organisms,' nested ecosystems built from innumerable cellular 'selves.' According to developmental genetics and systems biologists, autopoiesis, literally 'self-creation', is a central force of living beings. Life continuously generates and specifies its own organization autonomously. *But* this is done through a constant process of opening up to other bodies to nourish the self. Biologist and neuroscientist Franciso Verala described every single cell as a "process of creation of an identity."[47] That shape of self is paradoxically totally dependent on its surroundings and the flux and exchange of matter that is not itself yet. Living beings create individual autonomy and freedom thanks to their engagement with constraints.

Over the years we have often had our hope in any large-scale social change shattered when witnessing 'radical' spaces close themselves to the uninitiated, becoming ghettos, building judgmental walls of speech and style, acting from fear of difference. So-called 'radicalism' too often becomes a question of individualistic value and measurement. Many zad conflicts were over these questions of openness, based on fears by some that the zad's radicality would somehow be watered down if too many 'normal' people got involved. Often, this approach presumes that it

is possible or desirable to achieve some kind of eternal political purity, but purity easily slips into the antechambers of authoritarianism, it is poison against the power of plurality.

To sense our movement's differences, picture a long assembly co-organizing one of the actions to conjure away the evictions. Over a hundred people fill the barn of *la Vacherit*. Dairy farmers sit next to anti-speciesist vegans, tractor-driving libertarian communists who provide tons of communal potatoes are opposite primitivists refusing to have any petrol vehicles or even agriculture near their dwellings. There are feisty retired women from the local towns beside spaced out barefooted hippie runaways. There are deserting engineers and ex-convicts, drunk punks with dogs and fluffy ecologists, black bloc anarchists next to an ex-mayoress. There are even trade unionists from Vinci, the very workers who would build the new airport but have come out against it: "We are neither mercenaries nor slaves," they declare. "We do not want to work in a climate of civil war. We want to work on projects that we can be proud of because of their usefulness to society."[48]

Within the movement, this ecology of struggle is referred to as its composition. Instead of trying to 'resolve' differences, it requires each component to try to work together to pursue common desires that go beyond what was thought possible alone. Through the encounter of differences there is a process of contamination, whereby all change each other. Farmers become squatters and squatters become farmers; locals are radicalized and radicals become locals. Within such a composition, the

idea is not to convince others that one has the 'right' political line on nonviolence or the right to self-defense, on veganism or pastoralism, etc. This divisive attitude too often leads to movements splitting or becoming brittle monocultures.

This process is far from easy and never devoid of conflict. But when a composition works best, it reflects the self-organizing balance of conflicts and mutual aid, competition and partnership, of organisms. In an ecosystem's short term, everyone is eating, digesting, and becoming compost for each other, life is a constant flux of breaking apart and being remade. But in the long term, only behaviors that enable the whole ecosystem to flourish are amplified. Whether it is a prairie or an ocean, a forest or your gut, each interrelated part meets its own needs while creating the conditions that support and transform the whole. "In the ecological commons," writes Andreas Weber, "the individual can realize itself only if the whole can realize itself. Ecological freedom obeys this form of necessity. The deeper the connections in the system become, the more creative niches it will afford for its individual members."[49] Perhaps we should call the movement process a *compost* pile rather than a *composition*. After all every collective here has one, we all know that those dense piles of rotting beings, nourishing and transforming each other brings fertility. In a compost pile everything is cross contaminating, nothing is pure. Making movements as compost is taking the risk of doing things together, not just sitting around talking about radical ideas. This is not about the over comfort of a *safe* space, but as educators

Brian Arao and Kristi Clemens write,[50] it is about building a *brave* space. And brave spaces balance on that creative edge where we learn the most, neither in the panic zone nor in the comfort zone, but betwixt and between.

Autumn 2016 came fast. In Parliament, Valls declared weekly that the evictions were ready to roll. Each night, we went to bed wondering if heavily armed police would wake us up by breaking down our caravans' door. We memorized where our food, water, and gas masks were hidden. For weeks, every cold morning dawn, groups took turns scouting the nearby roads to check if the troops and bulldozers were on their way. Meanwhile, 1,000 people of all ages attended a series of playful weekend-long trainings, rehearsing resistance on the bocage, and hundreds of farmers prepared to block the region's infrastructure. The intensity of relationships that were nurtured during these stressful months built an irresistible force.

On October 8, when the threat of evictions peaked, 40,000 people converged from three points on the zone for a choreographed ritual, beautifully disguised as a demonstration. Each had brought with them a walking stick or staff, which they stuck deep into the earth, making a pledge that they would return to get their stick and defend the land if the government came to build the airport. "We are here, we will be here!" they promised. An earthen bank was transformed into a giant porcupine bristling defensively with 20,000 sticks. As the sticks were being planted, in the adjoining field the huge *Barn of the Future* was raised, with a banner attached: "No evictions here

nor in Calais," referring to the 'jungle' migrant camp the government was preparing to evict at the same time. The next day TVs across the country reverberated with Valls' broken record: "The evictions will happen. There can be no other way."

Medieval Futurisms

I believe that all organizing is science fiction—that we are shaping the future we long for and have not yet experienced.

adrienne maree brown, Black liberation social justice facilitator and healer[51]

On my way to yet another meeting to talk about the likelihood of state attacks, I cycle along a lane heading west, someone is playing the saxophone while people are weeding in the medicinal herb gardens, I pass the *Youpi Youpi* cabin, nestled into the woods where undocumented migrants have found temporary haven. On the right, is the *Cabane non mixte* for women and LGBTQI+ folk and the brewers' hops plants twisting into the sky, the *Gourbi's* mud dome, filled with memories of tense weekly assemblies whisks by. I hear the sound of Basque spoken by folk from the squatted neighborhood of *Errekaleor* who are helping build the *Ambazada*, a hall dedicated to linking up struggles around the world. A friendly "salut JJ!" welcomes me as I pass the *Wardine* known for its loud experimental noise concerts, the long greenhouses of *la Riotière*, the cows on their way to be milked at *Bellevue*, and finally to the *Barn of*

the Future. As I cycle, I am filled with an uncanny sense of *déjà vu*. I have been here before, long ago. Except it was not in reality but fiction.

All of a sudden, I realize that I am now living within the pages of my favorite utopian novel, the late nineteenth century best-seller, *News From Nowhere*, written by William Morris. Today, he is mostly remembered for his wallpaper designs overflowing with entangled flourishing plant life, rather than as one of the precursors of a revolutionary situated social ecology. Deeply egalitarian in temperament, Morris dedicated the last third of his life combining poetry, design and political organizing within the rising international socialist movement, that he hoped would one day free workers from the suffering and hideousness imposed on them by capitalism. Only when work became joyful could beauty be twisted back into life, he believed: "The true secret of happiness lies in taking a genuine interest in all the details of daily life."[52]

His speculative science fiction novel begins with the protagonist waking up in the future, several generations after a revolution. What follows is a trip down the river Thames visiting collective farms, feasts, debates, and harvests, in a decentralized world without money or bosses, factories or large cities, where the sensuous pleasures of labor replaces 'useless toil,' where people's innate sense of beauty and love of the natural world is embodied in their meticulously crafted objects, gardens, and buildings, where everyone becomes an artist, designer, and performer of a shared egalitarian life.

I look up at the vast central nave of the *Barn of the Future*, with its carved animals and little bell tower, built with medieval carpentry techniques. Morris would have adored it. For him medieval barns were "as noble as a cathedral" because they were material expressions of a precapitalist world, where capitalism had not put a wedge between art and work, and where the rhythm of the market did not dominate labor. For Morris, capitalism meant pain and ugliness, while within medieval craft culture we could see that "no human ingenuity can produce such work as this without pleasure being a third party to the brain that conceived and the hand that fashioned it."[53]

Happiness emerging from human activity and out of friendship and camaraderie was the leitmotif of his vision of a post-capitalist future, where work and play entangled and everyone chose their labor as an expression of their passions, thus taking pleasure in it, for its own sake. If the work was unpleasant, it was the way in which that work was honored by others that provided fulfilment. For Morris, *this* was art, simply "the human pleasure of life," the joy of labor, not a luxury object for the rich or a museum, but an ethos to be acted out in society.

Understood in this way, art extended well beyond "those matters which are consciously works of art," he wrote "to encompass not only painting and sculpture, and architecture, but the shapes and colors of all household goods, nay, even the arrangement of the fields for tillage and pasture, the management of towns and of our highways of all kinds; in a word . . . the

aspect of all the externals of our life."[54] Artists, in turn, were simply those who were committed to standards of excellence in their daily work: "what is an artist but a workman (sic) who is determined that, whatever else happens, his work shall be excellent?"[55] Morris' ideas on art, life, and politics are perhaps more relevant today than they ever were, and there is a certain taste of his ecological communalist medieval futurism here on the zad.

As winter 2016 approached, we at the *Laboratory for Insurrectionary Imagination* and our friends began the construction of another symbol of permanence and a big fuck off finger to the authorities. On the very site where the airport control tower was planned, at *la Rolandière*, we began erecting a full-scale working lighthouse, to welcome the world to port. For five months, a ragged crew—including deserting architects, a (no-longer) homeless kid, a ceramicist, a few farmers, and a genius welder (whose day job was building the world's biggest cruise liners in France's largest shipyard)—built the 20m high lighthouse. We took inspiration from rebel towers throughout time: We inhaled ambition from Vladimir Tatlin's never built 1919 vision of a 400m tall twisting, helix-like monument to the Communist International. We drew doggedness from the 60m high metal vertical barricade that farmers, students, and activists had built in 1972 to block planes taking off from the fiercely contested Tokyo international airport. Our audacity came from *Dolly*, a 30m crazed jumble of stolen scaffolding with a techno sound system at its summit that, in 1994, rose out of a row of 45 squatted houses in East

London, occupied to oppose the building of the M11 Link road.

An archetype of hope and haven, lighthouses are ancient tools for caring for the lives of those at sea and a form of commoning: their light is freely given to every ship to help it navigate safely through the night. Resisting wave and wind, stretching between sky and earth, lighthouses appear out of the darkness just when you think you're lost and are longing for home. Ours was built from a felled pylon for high-voltage power lines given to us by a farmer and connected by a shiplike gangway to the zad's library in homage to the mythical city of Alexandria, that melting pot of sailors, traders, and alchemists, with its great library and stalwart lighthouse. A symbol of confidence and tool of resistance, our lighthouse became the new, more elevated, pirate radio station antenna. On top was a siren controlled by mobile telephone to warn the zone in case of evictions. And we would lock ourselves to the skeletal metal structure, making it difficult for them to reach us in case the cops did come.

The lighthouse, like so much on the zad, was enabled by solidarity acts of every shape and size, little miracles that remind us of the etymological root of the very word miracle: "an act that makes one smile." From the gift of the pylon to the sharing of tools and skills, from the unexpected donation of a lightning conductor to the surprise delivery of a perfectly sized gangway, the donation of all these materials from the broader community was a powerful reminder of what a real culture of rebellion means.

Not everyone is able to be a frontline activist. Most people are not psychologically suited for direct clashes with cops, or they have life circumstances that reduce their capacity to take physical risks, like being arrested. Yet everyone can be part of building a culture of rebellion: a set of values that embrace, encourage, and promote radical political transformation. Building and partaking in such culture is about learning to no longer 'play safe' and obey the norms and rules given to us, but instead, to identify what one can do from wherever one is, in order to support all those who are actively resisting.

For a while a banner hung outside one of the squatted farms read *Pas de barricadières sans cuisiniers* (no women on the barricades without men in the kitchen). This was to remind everyone that strong social movements need every role fulfilled, from the most spectacular to the most seemingly mundane. Every revolution has been held by cooks, medics, legal support, media relations, child and elder care, and the maintenance of safe resting and hiding places. When evictions were looming on the zad, local farmers organized turns for tending their cattle so others could come with their tractors and defend the land. Residents from surrounding villages offered beds, showers and food to those who had been on the barricades during military operations. Supporters from afar sent clothes, money or medical supplies. Doctors tended wounds, lawyers offered advice, mechanics fixed vehicles, electricians helped pirate electricity, bands played for free. Sometimes such acts are beautiful clandestine gestures of camaraderie.

After the 2014 antiairport riots in Nantes, some municipal workers from the city admitted to not putting too much mortar in-between the cobblestones they were setting . . . "just in case!"

On a misty December 10, 2016, just as we were lifting the 20m skeleton of the lighthouse with lumberjack pulleys and a farmer's telescopic handler, news came on the radio that the government would not pursue evictions. The airport was still officially on the cards, but elections were scheduled to take place in six months' time and the Minister for the Environment feared that images of evictions that could, in her own words, "finish in a civil war" would not be good for a Socialist Party's re-election campaign.

The following spring, millionaire investment banker Emmanuel Macron won the presidency and was passed the hot potato. In a typical demagogic move, he nominated a team of "mediators" to "re-examine the arguments" in favor and against the airport project.

Victory and Revenge

And then it happened. On January 17, 2018, Macron's Prime Minister Edouard Philippe, flanked by the Minister of Interior and Minister of Ecology, announced on live TV that the airport would never be built in Notre-Dame-des-Landes.

But, in the same breath, he added that the "outlaw zone" must come to an end and "illegal" occupants, that is all of us who have arrived since 2008 on the invitation of the *Inhabitants who Resist*, would have to leave or be evicted before spring.

The threat could not smother the profound, indescribable joy we all felt at hearing the news. Conversations with comrades at the time were a combination of elation and anguish. But overall, the sentiment that prevailed was that of having achieved something that was never supposed to happen, accomplished by sheer determination, strategic intelligence and uncommon solidarities. For weeks, there was not a day when we would wake up, leave the caravan, cross our collective's garden and not stop to look at the *Rohanne* Forest in awe, thinking "Whatever happens, you will not become a runway. And *we* did this, all of us. We did it."

A month after the announcement, 20,000 people came together to celebrate the victory and reassert the movement's commitment toward the defense of the zad. We paraded along the winding lanes accompanied by a 40m long marbled newt puppet made with a seamstress from the Paris Opera house. We celebrated with a rapturous conga dance around a full-scale wooden burning crashed plane, into which comrades from all over the country threw carnivalesque effigies of destructive infrastructures. We danced all night long to bands overjoyed to perform to honor such a unique moment.

But for our victory and everything that led to it, we would have to be punished. The state would have to take revenge for its humiliation; they had to undo the scandal of being shown to be irrelevant. Over the past half a century it has become an imperative of global governance to stamp out any hint of possible alternative futures,

or, when that's not possible, to make sure no one even hears about them.

As David Graeber so brilliantly demonstrated, the rulers don't actually mind the occasional protest or expressions of rage against them; what infuriates them is if any significant number of people begin to say "You lot are ridiculous and unnecessary, we can run our lives without you."[56] This is all the more so when you are visibly capable of running your lives without state institutions and against the grain of toxic individualism, and patiently (albeit imperfectly) paving the way for the reclaiming and rebuilding of the commons.

This was made evident when, after weeks of agonizing divisive internal debates as to how to face this new eviction threat, a delegation of trusted movement members handed in a proposal of an all-encapsulating global lease for zad land tenure to the prefect. It was juridically solid and would allow all "illegal" inhabitants to legally remain. The prefect's unequivocal rejection and response demonstrated everything about the battle being led against us: only *individual* leases would be accepted. But for us it was out of the question to leave this land that had been saved by 40 years of collective struggle and hand it over to ever larger industrialized farms, or to become a playground for greenwashers (plans for a windfarm project had already been evoked in the local press). For the whole of the movement it was clear: despite the state narrative trying to divide the 'good farmers' vs the 'bad zadists,' those who had prevented the bocage from being concreted over were the most legitimate to continue taking care of it. We

would not accept any atomizing or individualizing conditions in order to stay, individual leases were unacceptable and were unanimously rejected. We would stay, come what may.

And so, at 3.20am on the morning of April 9, 2018, we were woken by the breathless voice of our friend on the phone: "It's begun." We jumped out of bed and ran to our posts: Isa to the communications office, filled with computers, phones and walkie talkies, JJ to the barricades to livestream what would unfold. Hundreds of police vans had taken over the two main roads that pass through the zone. About 2,500 gendarmes, a fifth of the country's entire force, had been unleashed at a cost of 400,000 euros a day. It was to be the largest law enforcement operation the country had seen since May 68.

For four days that felt like weeks, the zad was engulfed once again in a warlike atmosphere. Helicopters and drones hovered continuously above our heads, drowning the spring birdsongs in a menacing growl. Robocops armed to the teeth lined up in fields and paths, and ruthlessly attacked all those who had come to protect cabins with a flurry of teargas, stun grenades, and rubber bullets. Armored Personnel Carriers forced their way through the barricades. The resistance was heroic, but the destruction of our community's homes proceeded at breakneck speed. If they had come with their bulldozers to build an airport, they would have been faced with tens of thousands of resistant bodies. But with that threat out of the way, the majority of anti-airport supporters were not as prepared to take major physical risks to stop

the bulldozing of a post-capitalist commons that continued to refuse to bow to all the demands of the state.

In the communications office, mobile phones kept pinging announcing the names of the most beautiful cabins and gardens that had been razed. Within three days, more than 40 dwellings had been destroyed and many fragile meadows devastated by the caterpillar tracks of bulldozers. I spent most of my days frantically sharing what was happening with the world, remotely navigating journalists through the bocage as cops tried to prevent them from accessing the zone, updating medical supply lists of items needed to treat the multiple injuries. In the first three days, no less than 11,000 teargas and stun grenades were thrown at people defending a certain idea of common entangled life. Three hundred were injured, some badly, many with sharp grenade shrapnel. The ceaseless explosions of the police weapons that echoed across the bocage made us cringe with fear: who might have been hurt? How seriously? The zad's welcome center was turned into a field clinic, staffed by volunteer doctors, medics, and healers with its own autonomous ambulance, that the police often blocked from leaving the zone for the hospital.

Amid the chaos, someone wearing a balaclava and full monk's robe stole a cop's truncheon and baptized a line of robocops with it; they were ordered to "return the state's property." A picnic of 500 people organized by the "white-haired contingent," a collective of pensioners, was charged by cops, drowning families in teargas.

After our assembly hall, the earthen dome of the *Gourbi* was bulldozed, carpenters worked day and night in the *Barn of the Future* to build a replacement. And one night in a stunning act of collective theater, despite the general state of tiredness that filled our bodies, we managed to carry the massive timber framed building over several kilometers. A mass of rubber booted feet walked in unison: it felt like a strange chimera shuffling across the bocage, part human, part millipede, part wood.

There were also thousands of acts of solidarity that proved a lifeline: French consulate parking meters and barriers in Munich were sabotaged; musicians sent specially composed songs; banners were unfurled in front of French embassies in Dehli, Helsinki, New York, and Berlin and even underwater thanks to rebel scuba divers. Zapatistas sent their solidarity. An open letter penned by architects and signed by 50,000 appeared in *Le Monde*, the widely circulating French daily, deploring the destruction of the zad's unique forms of inhabiting. On the zone, three activist field kitchens came to feed us—the cooks wore gas masks while peeling vegetables.

Every dark morning the long godlike finger of light from the police helicopter penetrated our caravan, shaking us out of our sleep, it seemed that even dreaming was a crime on the zad. We had always dreamed of living in an autonomous zone; on the zad it had been realized. We had deserted the metropolis to merge fighting and building, art and life better, and now we were fighting like hell for the right to build a shared life. Yesterday a stun grenade exploded in the air above JJ, it ripped bits

of bark off the tree; 50cm lower and that could have been his head!

Gambles and Barricades of Paper

After four days of battle, a sort of truce was called by the regional prefect. She appeared on TV waving an A4 sheet of paper in an absurd theatrical gesture. In front of an audience of intrigued journalists she proudly produced what she believed was her ultimate weapon to neutralize the zad: "the simplified form," a single page document where only individuals willing to write their name, their plot of land and their specific agricultural project would be allowed to stay. Anything not agricultural would not be permitted, no shoe making, no rap studio, no blacksmith, no garage, no carpentry. Just individual names, no collectives, no practices of commoning. We had ten days.

It was more than a publicity stunt. It was a cunning maneuver to play on the zad's internal divisions. It was, we later reflected, a "revenge against the commons."[57] The weapon was effective, sparking more heated painful arguments among us. And now, we were faced with a two-headed counterinsurgency strategy, attacking us administratively and militarily. To many the idea of signing the form was an act of dishonorable surrender, we just had to continue to barricade and fight to the bitter end. But we were facing armored vehicles and thousands of cops prepared to destroy everything if we showed no sign of compliance. And so, for many others,

including ourselves, there seemed to be no chance of winning solely on the terrain of confrontation this time, the balance of force was too unfavorable.

At the best of times, clear thought and constructive debate when faced with complex and divisive options is difficult. But after four sleepless nights with a third of our homes razed to the ground, hundreds of comrades injured and adrenaline coursing through our bodies, it was virtually impossible. We attended countless meetings and informal discussions, and went through entire ranges of emotions in a matter of hours: inspired by the lucidity of some, exasperated by the narrow mindedness of others, horrified by the obvious traumas unfolding . . .

Yet, after many hours of assemblies and discussion, an elaborate gamble was devised: the odious document meant to be a trap would be hacked. Rather than a tool of atomization, we would collectively attempt to turn it into something that reflected and protected the forms of shared life that had been developed over a decade on these lands.

A dedicated crew established an office in the zad's library that was nicknamed *The Administrative Self-Defense Bureau* and for 48 hours the building became an ant's nest of activity. Dozens of people, many who had spent the last days on the barricades, decided to put that same combative energy into building a barricade of paperwork. We ran around carrying folders, scrutinized maps, tapped on computers, met, and made calls. Comrades with legal and administrative knowledge strategized to transform the hyper-individualizing form into a

massively complex ledger to attest to and defend our collective interdependencies. On each form there would be the signature of an individual, but it was actually registered in the name of a group or collective. It was a way to refuse at once to obey the injunction to be atomized and to be restricted to agricultural projects. We thus reintroduced the flurry of craft and cultural activities that make the zad unique. And by demonstrating how each of these activities was deployed over a number of overlapping parcels of land, the portfolio presented a more realistic picture of our complex entanglements, interconnectivity, and common vision, instead of a monochrome landscape of individualized plots and enterprises.

The trick not only aimed to protect all those prepared to take part in the gamble but, importantly, it highlighted the deep logic of the commons, not as a pool of resources to be collectively managed, but as processes and reciprocal relationships to be always renewed. It illustrated how the zad is a universe away from the metropolitan logic of 'planning permission' that can only imagine a territory through the prism of single use, the logic of 'zoning.' In this logic, agricultural lands can only host farms (albeit factory-like farms), artisans are parked in metal and plastic zones on the edges of towns, and villages become dormitories. But our territory is alive with farming *and* forestry *and* carpentry *and* buckwheat growing *and* milling and pancake making *and* book lending. These are not just sitting side by side, they work together, live and feed each other: the blacksmith fixes farmers' and carpenters' tools, the library

fills its shelves with books on forestry, the brewer offers beers for the regular celebrations that give a collective rhythm to the zone.

In the end, the thick file our delegates handed to the Prefect contained more than 40 forms, augmented with colorful maps and explanatory texts. Her agents were clearly taken aback by the intricate and clever stratagem. Of the 70 living-spaces on the zone, 63 were covered by the forms. Seven collectives refused to be part of this tactical move. State punishment was immediate: the tanks returned and eradicated their homes. In a TV interview sitting in a black and gold marble hall with the Eiffel Tower as monumental backdrop; president Macron declared at least four times: "We have restored republican order."

Deep wounds were reopened and fueled the excruciatingly vicious debates that had been building up. The animosity expanded well beyond the bocage. The defiant journey of the zad, with its victorious outcome, had turned it into the epitome of radicalism for many people and many took this latest turn of events very personally. Quebec anarchist groups, Belgian radical ecologists, farmers fighting norms and regulations in the South of France, anonymous individuals on Indymedia: everyone had an opinion about how we could or should have reacted. Daily, open letters, denunciatory texts and angry responses were published; we heard of collectives being torn apart continents away because of disagreements about decisions made on the zad. Those of us who had taken part in the "gamble of the forms" were accused of being traitors or lauded

as strategic geniuses by people who had never set foot on the bocage. For us, it often felt confusing: it was impossible to be insensitive to the wounds and disillusion of those who felt betrayed, yet we profoundly felt that there was little else that could be done. The depth of political disagreement had never felt so heartbreaking.

A main criticism was that, in agreeing to 'normalize' our relationship to the state through legal recognition we were betraying the cause of autonomy for which we'd become the poster child. Some feared that by engaging in this path we would be forced to comply with every single clause of the leases in order to stay. But for those of us who took the gamble, it was, and remains, something full of uncertainties and potential pitfalls. In a profoundly wounded and traumatized zad, we betted on our own capacity to navigate changing conditions, inspired by an ancient strategy of noncompliance: the map is not the territory.

As James C Scott has shown, sometimes the most efficient way of evading the state's stranglehold is what he called "dissimulation": pretend to comply by producing a simulacrum of what is expected, but without its substance.[58] For this, we would need to trust the vitality of the politics, relations, values, and culture of resistance we had been building for years and begin to heal from the attack and the divisions, while being vigilant about becoming just another 'alternative' without teeth.

The "gamble of the forms" was a ploy that aimed to prevent the zad from becoming just another flash in the pan of history, another free

commune shining briefly but ending in bloodshed, a martyred experiment sacrificed on the altar of radical purity. If all had refused to sign the forms, we have no doubt that *all* the zadists would have been evicted, dispersed back to the four corners of the world. Despite the profound sadness at the departure of so many bitterly disappointed comrades, we who signed could not just let go of the ties we had built here to the locals, farmers, pensioners, city workers, and wanderers of all sorts. We could not leave the owls, the black and yellow squirming salamanders, the gnarly oak trees, the mud, and the swallows. We could not just sever ties with what philosopher of ecology Baptiste Morizot has called the "community of importance,"[59] defined not by the competing interests of its members but by the delicate and powerful bonds that link them.

One evening I went into the welcome space and began to cross out the 40 destroyed homes on the giant map. I tried to say their names out loud as the marker scraped across the wood; *Plui Plu, Far Ouest, Boîte Noire, les 100 noms* … A tiny personal ritual to help exorcise the collective trauma that has bruised so many of us. But I didn't get far. Sadness rose up my throat and choked me into silence.

A community is always more than the sum of its parts, more than its political ideals. You go about your life, taking part in meetings and harvests, banquets and maintaining the land, and before you know it, you have grown attached by innumerable and inescapable threads to people, to the trees, to the light over the mist in the

morning, to the secret paths that you were shown once while escaping cops, to the arguments and the reconciliations, to the honey and the bread and the vegetables that your friends share, to the wild parties until dawn, to the doubts and the certainties . . . You find yourself having grown a new subjectivity, one that is inherently rooted in and emerging from the territory. The more you inhabit a place, the more it inhabits you.

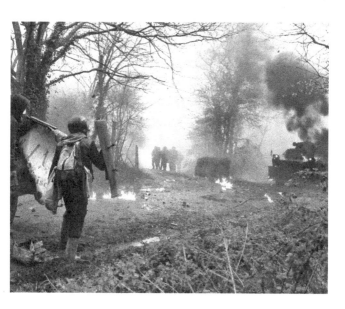

Tanks against commoners, Nina Lombardi. 2018.

Part IV: Flourishing

No Commoning without Commoners

Winter 2019. I feel like a clown slaloming between trees with my comically oversized orange boots and hard hat and my fluorescent thick trousers. I follow my friends, awkward and happy: today is the first day of the week-long collective logging in the *Rohanne* forest and, equipped with the appropriate (albeit ridiculous) safety attire, I have joined the group of novices learning the art of taking care of this small but precious forest, to which we now belong. My dad, a lorry driver, would be surprised but proud to see his daughter confidently carrying a chainsaw on her shoulder. We are going to be under the guidance of a dozen experienced comrades who have come from collectives and forest-based struggles all over the country. As measured by the commercial timber industry, it is a patch hardly worthy of interest—80 acres of 60-year-old deciduous and coniferous trees. But to us on the zad, it is a whole world of its own.

This is the forest where some of the fiercest battles took place during *Operation Caesar*, with its tree house dwellers, mud slingers and blockading pensioners. It has provided timber to build some of the most gorgeous cabins and buildings on the

zad, as well as firewood for the cold winter days. It has been the source of highly heated debates about the ethics of human intervention in 'nature' and the stage for theatrical candle-lit meanders by night. Left officially 'unmanaged' for years in anticipation of being eradicated to make way for the airport, it is today the subject of an arm-wrestle with authorities, adamant that they should regain full power over it. No agreement has been reached with the National Office for Forests, whose agents are the only ones authorized to extract wood in publicly owned forests. Walking in the footsteps of the commoners who came before us, whose survival was criminalized as 'poaching' by those who wanted to force them off this land, we are about to do what we do best: disobey.

"If you fell this chestnut tree, it will give more light to that young oak tree there, which is what you are aiming for. But you are going to have to be precise in your cut so as not to damage this other one on the way down." We spend more time with our necks crooked, staring at the canopy and discussing with our friends-turned-trainers how to go about cutting which tree than with our chainsaws in action. Our focus is put on taking care of the forest ecosystem, "not as in protecting something fragile" (although it might be), Carmine reminded us at the start of the day, "but in the sense of acknowledging mutual needs." The aim is finding the right balance between our needs for timber and firewood *and* those of the forest, so that it can continue to flourish. Obviously, what constitutes this equilibrium is the topic of numerous passionate discussions among the members of the

collective dedicated to taking care of the zad's woodlands and hedges, *Abrakadabois*—a playful portmanteau pun on abracadabra, the magic formula, and the French word for wood, *bois*.

The first felling of trees for timber in 2014 gave rise to serious ethical conflicts as some inhabitants of the zad were adamant that the forest should be "respected" and therefore kept untouched. But for many involved in what would become *Abrakadabois*, this view of a nature so pure it should remain unstained by human intervention, separated and museumified, is only the flip side of the modern coin that sees it solely as a resource to exploit. Idolization and exploitation are rooted in the same notion of a neat, deep separation between humans and their 'environment.' But 'we' are in and with and of 'nature.' Our greatest challenge is to learn to collaborate and participate with the living, rather than dominate it.

To move beyond these divisive conflicts, the group has committed to develop a shared vision and increased sensitivity through skill sharing, collective learning and a common appreciation of the forest. Since 2016, it has brought together passionate amateurs, an ex-forestry engineer, a gaggle of tree surgeons and lumberjacks, and has been organizing reading groups to share knowledge and questions about plant biology, the latest research about mycorrhizal symbiosis and the communication between trees, as well as anthropological texts on inter-species collaborations developed by hunter-gatherer civilizations around the world. These conversations nourish the elaboration of a common (albeit manifold)

perspective. This is enhanced by regular walks taken together to learn not only to recognize trees and identify possible diseases or specific behaviors, but also to analyze the impact that a previous cut has had on the growth and development of its neighboring trees, how it affects the lives of insects, the paths of mammals, etc. This same group determines each year which trees will be cut. Through attention and observation, we thus learn the web of interdependencies that is life, and progressively sharpen our ways of seeing.

I grab my chainsaw and get ready to fell my first tree. The deep thud of a tree being cut and hitting the ground nearby stops me in my tracks. It resonates in my chest. The unmistakable sound is at once heartbreaking and thrilling. My guide, Tim, gives me the last safety advice, reminds me to cut carefully but steadily. I am at once terrified and excited; although he is hardly a foot away from me and ready to modify the chainsaw's direction if I go wrong, I feel under the weight of a responsibility and apprehension. Not only do I hold a lethal machine with which I could easily chop one of my limbs off, but I am also about to take down a living being older than me that is home to a multitude of other beings . . . *and* the tree has to fall accurately, in order to protect its leafy neighbors, and not hurt any human in the process. The process of felling is meticulous; slowly adjusting the cut, observing the results, and adjusting again. It takes what seems an eternity and then the crown of the magnificent Douglas fir starts its descent, slow at first until it builds up speed and hits the ground. That crackle of

breaking branches, that thud. I am elated, shaken, awed . . . When I share my emotions with the group during the evening meal, even the most experienced lumberjacks talk about the strange mix of excitement, sorrow, and respect that they still feel with every tree they take down.

This profound sensitivity to our role in the forest makes this way of logging fundamentally different to what industrial standards impose. "A forest like this one is not interesting to the industry" explains Michel, who worked as a forest engineer before deserting seven years ago to live on the zad, "It is too small, the trees grow too close together because they were left 'unmanaged' for years. If they had it their way and took back this forest's management, the most probable option for them would be a clear cut." Clear cutting has become increasingly common and violent: nowadays trees are not just cut down—stumps are dug out and the slash (debris) is taken away to turn into the supposedly 'ecological' heating source of biomass, even though leaving it in place would protect the soil and the aquifer and aid in restoration. Then a monoculture forest is planted: rows of fastgrowing trees on an impoverished soil needing fertilizers (copper, phosphorous) that end up in drinking water!

Synergies and Regards

Against this extractivist logic, *Abrakadabois* has been learning from and networking with folk throughout France also researching, practicing,

and defending a silviculture that does justice to the inherent dynamics of the forest. As philosopher Baptiste Morizot describes, by taking the point of view of the forest, their practices are "full of regards for it."[60] This soft silviculture aims to work *with* the forest rather than against it, caring for its limits and ecosystems, extracting wood while preserving, even restoring, the soil and the tree health, and respecting the microhabitats with a careful holistic approach that recognizes we are not in the forest, we are part of it and it is part of us. It is all about progressively forging an "alliance of needs" between humans and more-than-humans, made possible by the diversity of approaches and ways of seeing: naturalists and lumberjacks, amateur tree lovers and professional foresters, sawyers and inhabitants. As philosophers Léna Balaud and Antoine Chopot describe "This (. . .) changes the experience of the forest: by allowing everyone to go beyond one's own identity, it multiplies the beings and relations to take into account."[61]

Such an approach implies the careful observation of moon cycles and only felling trees during the descending moon when the sap is at its lowest. It includes observing traces of boars who like to rub on trunks and adapting the felling accordingly. It means experimenting with anaesthetizing trees using a string tied around the trunk and snapping it (like one would a banjo) before cutting. It means working toward plant and animal diversity on a plot with introduced ill-adapted Sitka spruce species that has acidified the soil and turned a corner of the forest into a dark island of mono-

culture. Away from the industrial obsession with straight and rapid growth for profitable harvest, regards for the forest mean making space for 'non rational' selection criteria. Aesthetics or collective history become as valid stewardship guidelines as biodiversity or wood production. For instance, particularly alluring or bizarre trees are being preserved for the love of observing them develop, and a part of the forest where intense fighting took place in 2012 has been turned into a protected 'sanctuary.'

It also entails using draught horses instead of tractors to haul logs. "It is not a nostalgic or backward move," explains Steph, one of the handlers of the four huge workhorses that her collective has brought from the South of France to help out. She gives crisp, cryptic directions for her four-legged assistant to drag the tree we have just felled and pruned all the way to the forest edge where it will be sawn in a few months' time, their actions a synergistic duet. "Horse skidding" is often more efficient than tractors. She adds "It avoids soil compaction and also allows for keeping trees nearer each other than in industrial plantations that are designed for machines to get through. Besides it is so much nicer to be with than super noisy and smelly engines!"

The "adjusted regards"[62] for the forest is not just about an exalted love of trees. It represents a holistic understanding of the ecosystem. For this regard to be coherent and genuinely "adjusted," it must expand beyond care for the forest itself and take into account what comes next. This approach has been coined "from the seed to the beam":

applying the same attention every step of the way. This outlook privileges ultra-local uses of the wood from the forest, as well as an effort to adapt one's practices to what is there. Zad carpenters and architects have been learning to build and design on the basis of what the forest offers. Instead of using industrially standardized joists and planks, which mean lower quality wood and massive waste, the craft of using naturally shaped wood has returned, notably in the long-term work finishing the magnificent *Barn of the Future* that now holds a sawmill and a range of carpentry machines that shape the floorboards, joists, window frames, doors, and furniture of future constructions. This shared vision is precisely what industry has destroyed through fragmentation: those who identify the trees to be felled are not those who will fell them who are not those who will saw them who are not those that will utilize them as firewood or lumber . . . This compartmentalization and separation degrade ecosystems and relations.

The forest is too small to provide timber and firewood for all 170 zad inhabitants. Choices are made through a customary yearly process that is a cornerstone of commoning. An estimation of the quantity of wood available is calculated, and people and collectives attend a series of assemblies to discuss wants and needs and determine priorities. Each construction project is carefully examined, and a carpenter helps to calculate the precise wood requirements. Collective projects that serve the whole community are prioritized.

Some of the wood is systematically dedicated to support other struggles: bunk beds for a migrant squat in Nantes, a 'combat' wooden structure in support of an anti-gentrification campaign in Marseilles. Sustaining material links of solidarity with other struggles far and wide has always been part of the heartbeat of the rebel bocage.

As we are writing these words, the battle with the authorities continues. *Abrakadabois* seeks to be able to look after the forest as an ally, rather than as a resource. Negotiations are ongoing to pursue our lives in ways that are congruent with what we have defended. Specific long-term leases negotiated after the infamous forms and securing about 800 acres of farmland have been signed by those initially referred to as "illegal occupants," but this only concerns the land; housing remains unresolved. In effect, we are all still squatters. Our aim is to sign leases that acknowledge the territory as a commons. Crop rotation is organized communally and the Users' Assembly sits every month in order to make the decisions affecting the movement and the territory. National campaigns of action against toxic infrastructure are launched from the zone. A specially designed mobile street apparatus enables meals to be served on protests. A regional network of farmers has been set up to provide food for striking workers. And on the zone, illegal buildings continue to rise when necessary. Even though the airport struggle is over, we continue to try and keep the "yes" and the "no" twisted together.

No Commoners without Rituals

Each pathway into the forest has one: a wooden post made out of a chestnut plank crowned with an engraved sigil. This is a technique developed by the instigator of 'chaos magik,' artist and intuitive magician, Austin Osman Spare. These are magical glyphs that condense the letters of a written statement of intent into a single abstract image, which aims to influence the world. The idea is that that image is charged with the feelings of pleasure 'as if' the intent had already manifested, thus bypassing the desire to make it happen and jump into the prefigured future directly.

One fresh spring day in 2019, just before an *Abrakadabois* onsite meeting with the National Office for Forests, several dozen of us, each carrying a long slender chestnut branch, its tip painted white, walked around the edge of the entire forest and beat its bounds. We followed two tall masked figures, the *meristems*, dancing beings covered in multicolored glittering disco fringes. Meristems are undifferentiated cells that trigger new growth found in every bud and at the tip of all plant roots. Where pathways enter the forest, we thrust our planks into the soil, a silver bag of wine was passed around from which we drank, then spat a libation on the sigil to charge it. Finally, we converged around a giant burning hammer made of straw. The intention of the ritual was to protect the forest from the state's tree-marking hammers, which they use to 'manage' it. When the officials came to negotiate, our delegates arrived buoyed by

the ritual and the officials were slightly unhinged by the strange sigils that still smelled of wine.

Beating the Bounds is an ancient rite. The edges of a community were walked and marked not just to beat away undesirable spirits, but also to create an embodied map of a community's limits. The commons came into being as its inhabitants walked them together.

As the enclosures swept over Europe, with their surveyors and eye-in-the-sky paper maps, many rituals and festivities were pushed into extinction as the common lands where they took place were privatized and out of bounds. The practices of reverence and reciprocity—harvest feasts, winter carnivals, solstice and equinox rites—died.

As Silvia Frederici shows, in *Caliban and the Witch*,[63] concomitant with the rise of capitalism and the enclosures, which came partly as a reaction to radical peasant revolts, was the war against women. The church and state forced their bodies, via the threat of being burned at the stake, into becoming working tools of capitalist reproduction by systematically undermining their power and autonomy. The world had to be "disenchanted" in order to be dominated, writes Federici. Belief in magic—which was based on an animistic conception of nature, where the cosmos was an interdependent living organism, where every plant, being and body was a sign, with sense and meaning—had to be destroyed. This is no different from the violence of the colonizers around the world who outlawed Indigenous peoples' ceremonies so as to steal their land and the ritual objects that linked them to it. "Imperial

violence is not secondary to art but constitutive of it," writes political theorist Ariella Aïsha Azoulay. "Violently separating people from the objects they hold in common, and objects from the communities that create them and give them different types of meaning, is what we now call art."[64] As the looting of the enclosures and empire spread, the idea of art for art's sake flourished and art lost its worlds, becoming universal, detached, and transcendental.

After the enclosure of space came the attack on time. The preindustrial year was set to the cyclical soundtrack of numerous seasonal feast days. To destroy attachments of the commoners to all that was or could be common, time was stolen too. In 1834, the Governor of the Bank of England reduced public holidays from 36 to four.[65] The enclosures were "worse than ten wars,"[66] lamented an English commoner in 1804. They did not just rip people from their access to a sustainable livelihood, they also tore from them the inner emotional experiences of interdependence that such rites provide.

The last official pronouncement that the French state made after the 2018 evictions was by the interior minister, who declared on BFMTV, "you will never hear about Notre-Dame-des-Landes again." The state had tried to eradicate our forms of life and now it wanted to make sure that our story was over, forever. Still today we meet people who ask us, surprised: "Does the zad still exist?" But its story is engraved in our flesh, trauma traps itself in the tissues of our bodies, we carry it, whether we want to or not. JJ has had

half his face paralyzed twice over these years, following a burnout that sapped much of his energetic passion, forcing him to withdraw from many collective processes. Several months after the evictions, Isa felt so mentally exhausted that even the most simple tasks became mountains, everything had the capacity to overwhelm her. In the community we saw many of the telltale signs of post-traumatic stress: irritability, depression, anxiety, numbness. And ironically, we realized while writing this pamphlet, that our memories had become sketchy, there were huge blanks, another classic symptom of trauma. It took many conversations with comrades to weave back events and emotions. A few friends were loath to revisit those times. Reluctance to talk about a trauma is itself a symptom of trauma, and with all the conflicts and loss of trust, any possibility of collectively working to heal it as a community had evaporated.

This was the situation from which emerged the C.A.R (*Cellule d'Action Rituelle*), a collective created following a chance meeting of *The Laboratory of Insurrectionary Imagination* with "h," a duo of artists amid the clouds of tear gas one morning during the evictions. The C.A.R was launched with a ritual designed for the first anniversary of the abandonment, January 17, 2019, that the zad has declared a public holiday. The giant marbled newt puppet built for the party to celebrate the cancellation of the airport was brought out of storage and given a huge red velvet heart, broken in two. Ghostly 3m tall riot police with monstrous glowing red eyes were felled, a special song about

rebirth from the ashes sung. At the climax the newt's heart was repaired by mud masked spirits together with hundreds of folk binding it with red rope. Newts have special cells that enable them to self-repair their hearts if damaged, it seemed a fitting metaphor for a rite of passage from one zad to the next, a ritual to come to terms with our loss together, to connect us to each other and our more than humans accomplices, who have taught us so much about how to live. The ritual ended with the lighthouse being switched on to the sound of Bonnie Tyler's *Total Eclipse of the Heart.* The crowd danced inside the newt as it wound its way to a sumptuous banquet in a circus tent on the other side of the forest.

We believe the difference between art and ritual is that a ritual is not a reflection, expression or representation of a world, it is a tool to create and transform it. An important ritual for us is May Day, because it is as political as it is pagan. Its roots are in Beltane, celebrated on the eve of May 1, a fire festival honoring the explosive fecundity of life in springtime. In many parts of the world this is marked with the erection of maypoles, connecting earth and sky. Traditionally, folk danced around them and, often, orgies followed. Perhaps it's no coincidence that, in 1887, revolutionaries used the next day to rage against death, organizing demonstrations to commemorate the execution of seven anarchists following the Haymarket bombings the year earlier. Within a generation, May Day had become international workers day.

It is our favorite holiday because it weaves together ecology, communism, and anarchism.

On May Day 2000, JJ was busy with *Reclaim the Streets*, co-organizing a mass guerrilla gardening action where 8,000 people dug up the lawn in front of the British Parliament to plant vegetables and Winston Churchill's statue was infamously given a grass mohawk. In the good old tradition of May Day, it ended in a riot. Exactly 20 years later, we found ourselves with a horse named *Wings of Heaven*, poaching a storm-felled tree out of the forest of *Rohanne* with which to make a maypole.

Three huge bonfires lit up the night, a snare drum rattled, and, echoing an ancient tradition intended to protect livestock from pandemics, the zone's oldest cow was led through the smoke. In the *Ambazada's* hall, people were making a huge crown of flowers and preparing, stripping and painting the 20m long spruce, to be raised by hand the following day. Aphrodisiac cocktails were served, and a film played as backdrop: shots of sea coral squirting eggs, slugs twisting in their blue psyche-delic mating goo, microbes dividing and other forms of life's flamboyant fertility, intermixed with footage from May Day riots across the world. The next morning a solo violin played in the prairie as we carefully lifted the maypole into position. Once vertical, Cam climbed up high to undo the pulley ropes. She was crowned May Queen. A few days later she was pregnant.

Last week we baptized Cam's 3-month-old baby, Mady Hima Beltane, beside the maypole. There was confetti, a Disney song, pigs blood, and ale from the brewery poured from a magnum that was last used to celebrate the sending off of a comrade to fight alongside internationalist

comrades defending the autonomous region of Rojava, Kurdistan. As the sun set, we walked through a giant glowing red vulva made from willow, tasted a symbolic 'vaginal' fluid that brings bacteria and immunity to a newborn, and began a themed costume party, whose invitation summoned decadence and a long list of themes: Sequins, Gorgon, David Lynch, Voguing, Josephine Baker, Pan, Frida Kahlo, and Kiddy Smile!

Ritual is the theater of magic: transformation through communication. It is the ancestor of all art and its future if we want to build worlds that reclaim the commons, rather than nourish extractivist culture. Like carnival, ritual erases the space between performer and public, life and art. It replaces extractivism with care, representation with reciprocity, and it gives back the force of a specific time, place, and community to art.

The shared values, emotions and purposes of commoning need to be cultivated. Scholars David Bollier and Silke Helfrich call this "ritualizing togetherness,"[67] and it works best when dissolved into everyday life. Every Monday in many living collectives of the zad, cleaning and meetings mark the beginning of the week. At our collective, *la Rolandière*, we put on loud dance music and a dozen people get down with their mops, buckets, and brooms. Rather than a lonely chore, housework becomes a shared joy.

The primary characteristic of the commons is that there is no separation between users and objects, everything is bound together in relationships of reciprocity and mutual co-creation, it is

an interconnected dance of life and death, giving and receiving. Commons are complex networks of mutual transformation, yet always aiming for a higher goal: to create the greatest possible fecundity for all, to make sure that life continues to give life.

This process of mutual transformation is also a primary characteristic of life itself. All bodies and beings, from the cells in your hands to a blue whale in the Indian ocean, become 'self' through reaching out, touching, inhaling, and transforming each other. There is no self without other. The breath you just took in was the exhalation of plants, who in turn breathe in broken down bits of the carbon building blocks of your body in the form of C02. When you breathe out, you are giving some of your body away to others.

This metabolic process is far from the deceptive image of life our biology teachers taught us, of engine-like bodies that ingest fuel and spit it out as exhaust. Machines remain the same, but bodies are always changing. Life only becomes possible because each body splits off a bit of itself to become the other's body. Self-is-self-through-other, a deeply erotic process.

Commoning on the zad has taught us that to build a revolutionary force we must orchestrate all the dimensions of resistance (self-defense and disobedience), material means (places to meet, production of food, etc.) and affective work (through culture, songs, poems, etc.). With regard to this last dimension, rituals are key to galvanizing our collective affective strength. They are moments of connection where we can clarify common

visions, mourn or celebrate victories together. In ritual, we recreate our ties to each other. We are reminded what true freedom is: a paradigm shift from the isolating, disconnected free electrons of the *I*, able to do what it wishes, promised by capitalism. Rather, ours is an embodied freedom, where communities of humans and more-than-humans are nested, entangled and tied up with each other. Without our relationships to our food and friends, air and water, land and lovers, we are not free to flourish at all. We are not only embedded in relationships; our very identities are *created* through relationships. Rituals help sustain these reciprocal relationships, they mark and enable change and yet frame the continuity of life, with its repetitions and cycles, they are balancing acts. Most importantly they give gratitude and remind us what it means to be part of a commons made up of so many other perspectives.

"To practice magic, we can't simply honor nature's cycles in the abstract," Starhawk reminds us. "We need to know them intimately and understand them in the physical as well as the psychic world. A real relationship with nature is vital for our magical and spiritual development, and our psychic and spiritual health. It is also a vital base for any work we do to heal the earth and transform the social and political systems that are assaulting her daily."[68]

Life is Feeling

The police helicopter is making its regular rounds, its bone-rattling clattering still makes

my guts twist, three years after the last evictions. A parchment-colored cricket is exploring the bookshelves in the caravan. Every now and then she turns toward me. We look at each other for a moment, a stare which acknowledges that she is an autonomous being, a sensing, feeling, expressing organism, made of vulnerable flesh, as am I. Like all organisms at every scale, she has a core self, a concern for her own wellbeing. Her body, like mine, is constantly resisting the inevitable stillness of death, expressing a desire to stay alive, unfold and exist. To hold onto the joy of life.

Another beautiful paradox of life is in that moment of our eyes locking, in the recognition of total otherness, and yet absolute connection. How can I ever understand what it is to be a cricket? Yet we both sense what the embodied experience of aliveness is. If I grabbed the cricket between my fingers, and decided to squeeze the life out of it, I would see it struggle, arching its muscles in trauma, the same gestures and dance of death that my body would express if I was suffering a similar fate. All beings, even cells, consciously or unconsciously show what they feel is happening to them through their bodies. To understand others, we have to recognize that all lifeforms are made of the same expressive stuff as us.

How we understand life itself will decide our future. The classic models of biology, a little under 200 years old, created the conceptual framework that enabled us to turn the world into a resource. But this blindness toward what life is, is being shaken to the core. In fact, the revolution is as profound as that of a century ago, when relativity

and quantum theory reframed Newtonian physics. Now biology, with its ability to sequence genes, to look deep into the microcosmic world, correlate huge data sets and study the entire genome of a being, is showing us what so much traditional and Indigenous knowledge knew all along. Life is not a machine, made up of discrete building blocks, but a dynamic interpenetrating interrelating whole. It does not calculate but feels, it is not dead matter, but alive and expressive at every scale.

Something that the Cartesian worldview sought to purge from human understandings of life is returning. It seems that we can only understand living beings if we reintroduce subjectivity. Experiments show that when two genetically identical seeds are put in identical settings, each one grows very differently; each one is a self, committed to its ongoing existence in its particular body embedded in, and interpreting, a particular place. As their roots emerge from the seed, there is nothing deterministic going on, they are not just following orders from efficiency obsessed DNA, nor do they just fumble about randomly; they *choose* to head toward what will enable the plant to maintain itself and flourish. The roots reach toward water, friendly bacteria, fungi, minerals; they turn away from what is toxic. This biology revolution, as Andreas Weber says, shows us that organisms are "starting to be seen as a subject that interprets external stimuli and genetic influences rather than being causally governed by them."[69] We could imagine DNA as like a musical partition, interpreted by musicians.

Organisms seem to act according to values and create meaning, because they sense the world. This is not necessarily about cell *consciousness*, but we could view this as *intelligence*. The Latin verb *intelligere* means to be able to discern between things. This ability to choose existence, to experience a concern for a core self and express it, is the very definition of life. "If feeling is a physical force and the expression of this feeling is a physical reality whose meaning motivates organisms to act," writes Andreas Weber "then we might understand living beings better if we imagine what is happening in the biosphere as, in a way, resembling artistic expression . . . Art then is no longer what separates humans from nature, but rather it is life's voice fully in us."[70]

The most accurate scientific portrait of the oak I am looking at might not be just via measurements, but also exploring meaning: what does it mean to be this tree? What happens when we encounter her poetically, as if she were an ancient living sculpture, the palpable body of two hundred years of felt experience, the shape of subjectivity. Feeling is desire that emerges out of matter and also structures it. There is no mighty invisible vitalist force hidden inside the oak's xylem, but embodied feelings, made up of and from its needs and its sense that they are being satisfied. Life is an outside that is also an inside.

We see it in the way the branches twist and reach toward the life-gifting sun. We see it where its bark has grown around the barbed wire fence, where the scar of tree flesh bears witness to its past and its becoming future. The tree's body like

ours and every living body is simply a mirror of experience.

A warbler (whose French name *Polyglotte Hippolais*, means the many-tongued harmonious one) just came back from wintering in Africa. Its yellow breasts burst with song, resembling a merger of 90s modem sounds and vintage video games. No bigger than your fist, it can imitate dozens of other birds. It replays samples from species it heard on its journeys across continents, into a wild mix. Our society of separation used to say this beautiful song was just an advertising jingle, a soulless soundtrack saying "come fuck me" or "fuck off," another sonic weapon in the battle of biological survival and efficiency. But as physicist Karen Barad writes, everywhere people are "shaking loose the crusty toxic scales of anthropocentrism where the human in its exceptional way of being gets to hold all the 'goodies' like agency, intentionality, rationality, feeling, pain, empathy, language, consciousness, imagination, and much more."[71] If the warbler is able to imitate other species, then this mirroring, representing, and arranging the replay, suggests to ethologists that the bird's behavior has the ability of abstraction. It experiences that there is self *and* world and perceives that it can act on this world according to a point of view, a concern. Its song isn't a deterministic sequence of cause and effect, but a self freely expressing and celebrating the fact that it is alive.

Perhaps one day the arrogant idea that 'our' (Western) culture is somehow superior to 'their' nature will seem as obscene as the colonial logic

that divided the world between civilized and savage and provided the philosophical framework of genocides. The Western myth that 'nature' was the backdrop for the theater of humanity is crumbling. It was a treacherous blueprint for all the other destructive modern binaries— mind-body, sentient/non-sentient, male/female, straight/gay . . . The ontological shift that the West is living through gorgeously muddles, queers, and complexifies everything. Maybe all of life will be regarded as no different from art, because it too is simply form emerging from feeling.

I gently cup the cricket in my hands to take it out of the caravan. It leaps away, then hanging from a long blade of grass, turns back to look at me one last time before jumping with joy out of sight. I breathe in a sense of wonder, and with that amazement a deep connection to something so much bigger than my own just-human perspective. In that moment the traumas of eviction, the sadness, the grief for the world shift into a perspective the size of the universe, beyond and yet also within me. I become like a child, my senses enlivened and amazed by the newness of the world rather than an adult blasé by the darkness of our times. I am nourished by the connective power of wonder for everything that is alive, all those bodies that express their inwardness and concern for aliveness; remind me that we are never alone in this intelligent world that we are immersed in and part of, this world that is not a collection of mute mechanical somethings but a commons of creative someones, this world that we

have spent so many years fighting with and for. It all makes sense again.

Perhaps when the binary between nature and culture, this gulf between what is art and what is life finally dissolves, we can once and for all get rid of that great separating, individualist, anthropocentric word, which divides the expert humans that create from all those that don't, that worn out label: *artist*. Maybe we can replace it with Thaumaturge, meaning literally the workers of wonder. Not only you and I and every human are Thaumaturges, but the blade of grass, the crickets, the swallows, and the compost too.

200 Years of Art and the World Is Getting Worse

The oak tree towering over our caravan, who has accompanied us in this writing, was planted in the hedgerow not long after a 'Copernican' revolution in art was taking place in the white colonial metropolises of Europe around 1750. We sense a similar radical shift in perception opening up. In the laboratories of social and natural sciences, "human exceptionalism and bounded individualism," writes biologist and theorist Donna Harraway, "those old saws of Western Philosophy and political economics, become . . . seriously unthinkable."[72] We find ourselves at this fulcrum moment in history where life is in more danger than it has been for the last 200 million years, at the same time as our understandings of life are being revolutionized. Yet in the museums and studios, concert halls and theaters, galleries and

festivals, it seems that even though this era *should* make Art-as-weknow-it seriously unthinkable, business as usual continues.

As mentioned earlier, according to art historian Larry Shiner, Art-as-we-know-it is "a European invention barely two hundred years old"[73]—a bit older than classical biology but premised on an equally dangerous logic. Like notions of biology that beguiled us into believing that life is a competitive battlefield for survival, the idea of Art-as-we-know-it has been a weapon of capitalism and colonialism. Art with a capital A, the singular works of an almost always white, male genius, is presented as the definition of "advanced civilization," differentiating us from barbarians.

For most of human history, and in most of human cultures, there was no single word for art distinct from life. But something unprecedented happened around 1750, right at the very onset of the industrial revolution, a revolution in the perception of art also took place. Thanks to fossil fuels, industrialism was the first time the processes of making things became independent of human and animal power, disconnected from seasons, weather, wind, water, and sun. Making became independent of place, as coal and then oil amplified the logic of extractivism and the planetary plundering accelerated.

But among the rising middle classes of the metropolis, the violent rift was being formed between art and craft, genius and skill, tradition and invention, the beautiful and the useful, art and life. These separations continue to be the very foundation of the system of Art-as-we-know-it.

What was once the process of inventive collaboration, such as the guilds of artisans working on a cathedral, became the possession of individual genius. Works that once had specific purpose and place (including Shakespeare's plays!) were separated from their functional contexts. Altar pieces were ripped from their churches and put in the museums to become 'paintings,' music airlifted out of rituals or carnivals and enclosed in the concert halls. Before the 1750s, the myth of 'autonomous art,' a work existing primarily for itself, did not exist, neither did museums or concert halls. Before Art-as-we-know-it was invented, humans found a multitude of ways to express and celebrate what it felt to be alive. None asked to be called an artist. But like the land, art had to be enclosed to give value to the rising middle classes. Rough popular forms of culture were evicted and replaced with polite 'fine' arts, for reverential contemplation and collection by the rich. Promoted worldwide by missionaries, armies, entrepreneurs, dealers, and intellectuals, this new invention was another engine of 'progress' and a sign that the hierarchies being imposed were natural. A civilization that could produce what were presented as 'great works of art' was destined and entitled to rule. The idea and ideals of Art-as-we-know-it continue to colonize imaginations everywhere.

Art was thought to define humanity. Tolstoy saw it as the fundamental human activity whereby someone conveys through external sign, feelings they've experienced, thereby infecting others' feelings. But for 50 million years, eons before humans first painted rocks, the bower bird had

ground pigment from fruit seeds, painting bowers, and erecting maypole-like structures for mating dances. The humpback whale has rehearsed songs for hours on end, collectively casting a web of communication that echoes across the globe. Meaning, feeling, expression, creativity, and communication are not unique to humans, but the epicenter of what defines life.

The extractivist spirit in art must be exorcised. Despite artists' 'concern' about the issues, the most important thing to them is seldom how artwork can be part of solutions to the problem or how it can materially nourish a community or a struggle. The most important thing is that 'good' art is made. Despite all the claims of scholars, critics, curators, funders, and artists themselves, Art-as-we-know-it rarely if ever 'gives back' to or fights on the side of the world that is being destroyed. Most often the art that claims to do this simply benefits the artist's career and further legitimizes the institutions promoting this obsolete invention.

The word art is a portmanteau of the Latin *ars* and the Greek *techne* and for many thousands of years it was used to describe *any* human activity. Shoemaking, verse writing, horse breaking, governing, vase painting, cooking, medicine, or navigation, were considered an art. Not because it was done by an artist or because it was separated from the complexities of life by framing it within the contemplativity of the Art-as-we-know-it system, but because it was performed with grace and skill. Grace is an act of thinking with and thanking the world. The word comes from old French *Grace*, meaning 'thanks,' as in *grâce à*, as in

'gratitude.' To thank life for giving us life, that is perhaps the greatest skill our art must learn, and here on the zad we thanked the bocage by falling for her and fighting for and with her. Within her humid muddy lands, we learned what the art of life might be, an art overflowing with attention and reciprocity, an art animated with gestures of gratitude, an art that allows life to flourish, to be free—an act of love.

An Art of Life

> The sacred is not a great something that you bow down to, but what determines your values, what you would take a stand for.
>
> Starhawk, ecofeminist author, activist, witch[74]

And so here we are writing in the summer of 2021, in this crack in the system, where a global epidemic was added to the converging storms, and the line between what seemed unfeasible and what ended up being possible was smudged.

In many countries, artists and cultural workers, museums and theaters, galleries, festivals, and concert halls were ravaged by lockdowns. A social-media post by French cultural workers suggested that folk should keep up hope: art has emerged transformed through catastrophes, they said. It mentioned Dada, which grew from the rubble of empires and the massacres of industrialized war. Like successional ecosystems blossom after a wildfire, historically destructive periods often birth paradigm shifts. Not only Dada, but

quantum physics and jazz flourished in the wake of the chaos of WW1. But for Dada the catastrophe was *art* itself. Living through an apocalypse, Dada did not want to relaunch Art-as-we-know it, but abolish it, sabotaging and hacking everything that represented the values of a world that disgusted them. Against the machinery of death, their manifesto of 1918 ended with one word in capital letters:

LIFE.

On the bocage we have become the territory because it engulfs and nourishes our imaginations and our bodies. We know when the frogs spawn and when the buckwheat is ready to mill; we sense when the potatoes will be harvested and celebrated with a French fries festival; we notice when it's been too dry and the ponds become lifeless; we care when the amphibians mate and the message on our phone reads: "walk & drive carefully—it's the night of the fire salamanders"; we are familiar with the weave of green lanes because we learned them while ambushing the police.

By deserting the metropolis, we learned to pay attention, and practice an art of life. But as our friend, the philosopher Isabelle Stengers writes, the art of attention is not just giving ourselves to things a priori defined as worthy of attention, but obliging us "to imagine, to consult, to consider consequences involving connections between what we are accustomed to considering as separate."[75]

Countless people now hold the picture of the zad in their imaginations, like one might carry the

memory of a work of art: an image that reminds us that we can all shape our worlds otherwise. On the bocage, feelings and desire became form in the shape of a struggle that put life in common at its heart. To many, even though they would never term it thus, this land has become sacred, because they sensed its wonder and risked and dedicated so much of themselves to ensure it never became an airport. "Nothing is made already sacred," hermeticist and youth worker Orland Bishop reminds us. "It becomes sacred when we give our attention to it at a level that reveals what it holds as energy and information."[76] When land becomes sacred and struggle becomes an art of everyday life, magic happens.

The low sun sets through the hedgerow, we are looking out at the wetlands. These wetlands that continue to become wetlands, farmland that continues becoming food producing land. The airport will only ever be a negative shape, a ghost of the extractivist empire. Holding back the monoculture machine, decolonizing a place from capital, opening it up as somewhere that enabled forms of life to connect and unfold: that is what is beautiful. That is the aim of an art of life, an art that lets life live more.

An owl hoots in the distance and we are reminded of the incredible courage of nineteenth century abolitionist Harriet Tubman who used her knowledge of the living world to save so many lives. Tubman escaped from enslavement at age 27 and rescued hundreds of fugitives by guiding them up the Underground Railroad, the network of clandestine safehouses ferrying escapees to

safe haven. She mastered these long dangerous journeys through marshlands and forest, often tracked by dogs sent out by the authorities to sniff them out. She had grown up in the wetlands and had a complex understanding of the landscape, and she would mimic the call of barred owls to alert the refugees that it was safe to come out of hiding and continue their journey. Her accurate rendition of the call of the bird blended in with the normal nighttime sounds, and so created no suspicion. The lives of the freedom-seekers were saved; the wetlands continue to flourish.

We are 'nature' defending itself.

A salamander made for the victory party, Philippe Graton, 2018.

FUCK 'IT'!

Words must lead to action. How does this text translate beyond the bocage? How do these lessons help you to fight and build within your territories and communities, no doubt so different from these lands? We never wanted this pamphlet to be a blueprint, in fact within a situated pluriversal culture the idea of a blueprint is in itself part of the problem. We do not need any more floating, detached and inevitably false solutions imposed from afar or above, but we do need imagination and hope to keep on fighting for self-determination and autonomy from below. The forces of hope and imagination cross oceans and can enliven struggles with very different textures, they open potentiality and horizons however far away. Good stories need to travel like seeds.

As we finish the pamphlet the zad prepares for the arrival of a large Zapatista delegation visiting Europe for the first time, their struggle and stories from the jungles and mountains fed so many of our imagination in the late 90s. We were living lives in metropolises across the world, so different from theirs and yet their compelling imagination moved and mobilized us. Their autonomy continues to spread hope two decades on. "One no and many yeses," they proclaimed, a "no"

against capitalism, a "no" against binary thinking, a "no" we could all share wherever we were. And a multitude of different ways of imagining a future with dignity at its heart.

Perhaps we can end with a shared "no," a little ritual of banishment, inspired by author, mother, expert in moss, biologist, decorated professor, and enrolled member of the Citizen Potawatomi Nation, Robin Wall Kimmerer. She reminds us that language is a tool for cultural transformation, that words have power to shape our thoughts and our actions, and every revolution needs new grammars. The problem is that the English language allows no form of respect for our fellow more-than-human beings. In English, a being is either a human or an "it," an object. "We put a barrier between us, absolving ourselves of moral responsibility and opening the door to exploitation," she writes. "Saying 'it' makes a living land into 'natural resources.' Imagine describing our grandma as 'it',"[77] she asks us. To defend lands that we fall in love with and to enable us to realize that the land loves us back, we need new revolutionary pronouns that refer to the more-than-human not as things, but as our earthly relatives.

And so perhaps we are not 'nature' defending 'it' self, after all. Perhaps we made a mistake entitling this pamphlet thus, the binary logic was still lingering.

And so, let us banish together that pronoun, let us make a pledge together to never ever call another living being 'it' again.

Write 'it' large on a piece of paper.
Go outside.
Set fire to the paper.
Focus on the flames.
Shout as loud as you can, feeling as alive as
possible.
"Fuck 'it'!"

VĀG
ABO
NDS

Gratitudes

This pamphlet took many years to come to fruition, mostly because we prioritized fighting and building more than writing. A lot more humans and more-than-humans than we can thank here have contributed in some way or other to its making. Yet, we want to mark our deep appreciation to a few without whom, this little book would have remained hastily scribbled words in notebooks . . .

First and foremost, our editors: Marc for incredible patience and resilience at the project's numerous setbacks and delays and for his passion for a story that needed to be told; Max for his enthusiasm and attentive hard-core editing.

Oli for uttering the unforgettable words that gave us strength and direction when doubt was taking over.

Marsios who opened the first door to the zad with his bottomless generosity and who never ceased to will us to join what he called "the most concrete and imperfect utopia you'll find this side of the ocean."

Alain for gifting us his rebellious home on the zad.

La rolandière—Mathilde, Félix, Alise, Cécile, Tibo, Raf, Servane, Nao, Jeanne—our adored

living collective, for their patience and tolerance of our many absences on 'writing retreats' (and ned ludd the cat who still purrs when we come back).

All the Climate Games crew of 2015 and especially Yoann who led us here with his unparalleled calm and determination . . . (and for gifting us his and Alex's 'lux' caravan when they decided to pursue their own journey to the other hemisphere!)

Nico, Morgane and the kids; Etienne and Béa; Nicolas, Héloïse and the cats (and Xavier and Emilie who put us in touch); Flo and Léna . . . for offering us beautiful retreats that brought much calm and inspiration.

Kate, Robyn, Julia, and Beverly for being test crash readers.

Nat and Thibaud comrades in magic, Flaminia for her ritual electronic playlist, the plant medicine for intuition, tarot cards for choices, Andreas Weber for warmth and teaching enlivenment and Steve Lambert for designing the *self-control* app (and helping the war against online distractions!).

Martine, Yann and Aymeric for being there, always. Joanne, JJ's mum, who taught us to never separate head, heart and hand and is still there despite her passing.

We want to dedicate this pamphlet to everyone weaving together the arts of living, fighting and building the commons on the zad and beyond. To all those who are taking the risk to debinarize our worlds and last but not least to the oak tree above us who will be here even when the pamphlet you

hold in your hand is simply our ghost's body, its words a way to connect you to the dead.

And if you wish to connect to Isa and JJ in this life take a look at www.labo.zone

VAG
ABO
NDS

Notes

1. Ailton Krenak, *Idées pour retarder la fin du monde* (Lachaud: Editions du Dehors, 2020), p. 30 (authors' translation).
2. Suzi Gablik, *The reenchantment of art* (New York: Thames and Hudson, 1991).
3. Over a decade later, we realized that a deep undercover police officer had been in the organising group and that the Metropolitan police had known all along the target for the carnival. See: George Monbiot, "Did an undercover cop help organise a major riot?" *Guardian*, February 3, 2014, https://theguardian.com/commentisfree/2014/feb/03/undercover-officer-major-riot-john-jordan.
4. Lynn Margulis and Dorion Sagan, *What is Life?* (New York: Simon & Schuster, 1995), p. 236.
5. Andreas Weber, *Matter and Desire: an Erotic Ecology* (Chelsea: Chelsea Green Publishing Co, 2017), p. 36.
6. https://bbc.com/news/health-43674270 (accessed March 2021).
7. https://nytimes.com/2017/10/04/science/ancient-viruses-dna-genome.html (accessed March 2021).
8. https://theguardian.com/environment/2010/aug/16/nature-economic-security (accessed April 2021).
9. Interviewed in Sedat Pakay's film, *James Baldwin: From Another Place*, Hudson Film Works II, 1973.
10. Tim Flannery, *The Future Eaters: An Ecological History of the Australasian Lands and People* (London: New Holland Publishers, 1994).

11. https://activesustainability.com/environment/ natural-resources-deficit/ (accessed April 2021).

12. https://espas.secure.europarl.europa.eu/orbis/ sites/default/files/generated/document/en/ ESPAS_Report2019.pdf (accessed November 2020).

13. *Summary for Policymakers of IPCC Special Report on Global Warming of 1.5°C approved by governments,* 2018, www.ipcc.ch/2018/10/08/summary-for-policymakers-of-ipcc-special-report-onglobal-warming-of-1-5c-approved-by-governments/ (accessed November 2020).

14. Allan Kaprow, "The Real Experiment," *Artforum* 12, no. 4 (1983) p. 37, https://artforum.com/ print/198310/the-real-experiment-35431.

15. Vandana Shiva, *Monocultures of the Mind Perspectives on Biodiversity and Biotechnology* (London and New York: Zed Books, 1993).

16. Mauvaise Troupe and Kristin Ross, *The zad and NoTAV. Territorial Struggles and the Making of a New Political Intelligence* (London and New York: Verso, 2018).

17. For a detailed history of these moors, see the essay by ex 1968 Enragé and situationist, François de Beaulieu, "Usage of the Commons at Notre-Dame-des-Landes, Yesterday and Today," http:// notbored.org/Beaulieu.pdf.

18. https://globaljustice.org.uk/news/2009/jan/15/ flights-heathrows-third-runway-will-emit-samegreenhouse-gas-emissions-kenya (accessed December 2020).

19. This "Open Letter in the Dark," written in 2014 explains why we refused a major commission for an arts festival funded by Vienna Airport and develops our position on flying: https://labofii.wordpress. com/2014/10/28/an-open-letter-in-the-dark/.

20. See Isabelle Fremeaux, John Jordan, Kypros Kyprianou, fictional documentary film, *Paths Through Utopias,* 2019, https://vimeo.com/ 218495549.

21. Hakim Bey, *T.A.Z. The Temporary Autonomous Zone, Ontological Anarchy, Poetic Terrorism* (New York: Autonomedia; 1991), p. 98.

22. See Wendell Berry, "Distrust in Movements," *Clarion Review* (2014), http://clarionreview. org/2014/03/in-distrust-of-movements/ (accessed February 2021).

23. Peter Kropotkin, *Fields, Factories, and Workshops: Or, Industry Combined with Agriculture and Brain Work with Manual Work* (Eastford: Martino Fine Books Publishing, 2014).

24. Patrick Roberts, "The real urban jungle: how ancient societies reimagined what cities could be," *Guardian* (June 22, 2021) https://theguardian.com/news/2021/jun/22/the-real-urban-jungle-howancient-societies-reimagined-what-cities-could-be (accessed June 2021).

25. In *The Question of Power. An Interview with Pierre Clastres*, (Semiotext(e), 2015), p. 27.

26. James C Scott, *Against the Grain. A Deep History of the Earlier States* (New Haven: Yale University Press, 2017), p. 51.

27. Isabelle Fremeaux, John Jordan, *Les Sentiers de l'Utopie* (Paris: Zones/La Découverte, 2011).

28. See www.zadforever.blog for writings, videos and other English language media about the zad.

29. The Invisible Committee, *To Our Friends* (New York: Semiotext(e), 2015), p. 188.

30. Arundhati Roy, *Walking with the Comrades* (London: Penguin Books, 2011), p. 210.

31. Association Citoyenne Intercommunale des Populations concernées par le projet d'Aéroport.

32. Fred Turner, *From Counterculture to Cyberculture, Stewart Brand, The Whole Earth Network, and the Rise of Digital Utopianism* (Chicago: University of Chicago Press, 2006).

33. Suzy Gablik and James Hillman, *Conversations Before the End of Time* (New York: Thames and Hudson, 1995).

34. Paul Rabinow, ed. *The Foucault Reader* (New York, Pantheon Books, 1984), p. 350.

35. In Larry Shiner, *The Invention of Art. A Cultural History* (Chicago: University of Chicago Press, 2001).

36. La r.O.n.c.e (Resist Organize Create Exist) meaning *brambles* in French was set up with folk

from the French climate camp and two ex-inhabitants of the zad, both of whom returned to the zad when we moved there in 2016.

37. Alan Kaprow, *Essays on the Blurring of Art and Life* (Berkeley, University of California Press, 1993).

38. https://sciencedaily.com/releases/2020/11/201113124042.htm (accessed April 2021).

39. Isabelle Fremeaux, John Jordan *Les Sentiers de l'Utopie* (Paris: Zones/La Découverte, 2011), p. 146 (authors' translation).

40. John Jordan "The art of necessity: the subversive imagination of anti-road protest and reclaim the streets," in Stephen Duncombe (ed.) *Cultural resistance reader* (London: Verso, 2002).

41. Angela Davis, Lecture delivered at Southern Illinois University, Carbondale (February 13, 2014) https://youtube.com/watch?v=6s8QCucFADc&ab_channel=JamesAnderson (accessed November 2020).

42. Starhawk, *The Spiral Dance. A Rebirth of the Ancient Religion of the Goddess* (San Francisco, CA: HarperOne, 1979).

43. David Graeber, *Debt. The first 5,000 years* (New York: Melville House, 2011), p. 801.

44. Kasper Opstrup, "The Untamed Craft. Magical Activism as Reaction to the Reappearance of the Reactionary" (unpublished essay, personal correspondence with authors, 2018), p. 2.

45. Donna J. Harraway, *Staying With the Trouble. Making Kin in the Chthulucene* (Durham: Duke University Press, 2016).

46. https://terrestres.org/2020/08/23/cinq-questions-en-marchant-a-celles-et-ceux-qui-ont-decidede-rester-a-agir-pour-le-vivant/ (accessed September 2020).

47. Fransisco J Varela, "Patterns of life: Intertwining identity and cognition," *Brain and Cognition* 34, Issue 1 (1997), pp. 72–87.

48. *Nous ne sommes pas des mercenaires!* Déclaration de la CGT VINCI, https://zad.nadir.org/spip.php?article3732 (accessed April 2021).

49. Andreas Weber, "Enlivenment. Towards a fundamental shift in the concepts of nature, culture and politics," *Heinrich Böll Foundation, Publication Series Ecology*, vol. 31., https://boell.de/sites/default/files/enlivenment_v01.pdf. (accessed January 2021).

50. Brian Arao and Kristi Clemens "From safe to brave space. A new way to frame dialogue around diversity and social justice," in Lisa M. Landreman (ed) T*he Art of Effective Facilitation: Reflections From Social Justice Educators* (Sterling: Stylus Publishing, 2013).

51. adrienne maree brown, *Pleasure Activism: The Politics of Feeling Good* (Chico and Edinburgh: AK Press, 2019), p. 10.

52. William Morris, in the lecture "The Aims of Art" (collected in *Signs of Change,* 1888), https://marxists.org/archive/morris/works/1888/signs/index.htm.

53. 1879 lecture, Birmingham School of Art and Design: "The Art of the People," in *The Collected works of William Morris*, vol. 22 (Cambridge: Cambridge University Press, 2012), p. 41.

54. William Morris, "Art under Plutocracy," in A.L Morton (ed), *The Political Writings of William Morris* (London: Lawrence & Wishart), p. 58.

55. Ibid., p. 51.

56. David Graeber, in Jade Lindgaard (ed) *Eloge des Mauvaises Herbes. Ce que nous devons à la zad* (Paris: Les Liens qui Libèrent, 2018), p. 9 (authors' translation).

57. See our pamphlet about the 2018 evictions, *The Revenge Against the Commons*, https://zadforever.blog/2018/04/24/the-revenge-against-the-commons/ (accessed September 2020).

58. James C Scott, *The Art of Not Being Governed. An Anarchist History of Upland Southeast Asia* (New Haven: Yale University Press, 2009).

59. Baptiste Morizot, *Manières d'être vivant* (Arles: Actes Sud, 2020) (authors' translation).

60. Ibid., p. 267.

61. Léna Balaud and Antoine Chopot, "Suivre la forêt. Une entente terrestre de l'action politique," https://terrestres.org/2018/11/15/suivre-la-foret-une-entente-terrestre-de-laction-politique/ (authors' translation) (accessed November 2020).

62. Baptiste Morizot, *Manières d'être vivant* (Arles: Actes Sud, 2020), (authors' translation).

63. Silvia Federici, *Caliban and the Witch: Women, the Body and Primitive Accumulation*, (New York and London: Autonomedia; Pluto, 2003).

64. Ariella Aïsha Azoulay, *Potential history: unlearning Imperialism* (London and NY: Verso, 2019), p. 183.

65. *Rites de Passages*, in *zadibao*, an online and occasional paper publication emerging from the zad 2018–19, https://zadibao.net/2018/07/03/rituelle/

66. Kirkpatrick Sale, *Rebels Against the Future: The Luddites And Their War On The Industrial Revolution: Lessons For The Computer Age* (Reading, MA: Addison-Wesley Publishing Company, 1995), p. 35.

67. David Bollier, Silke Helfrich, *Free, Fair and Alive The Insurgent Power of the Commons* (Gabriola Island: New Society, 2019).

68. Starhawk, *The Earth Path Grounding Your Spirit in the Rhythms of Nature* (New York: Harper One, 2004), p. 15.

69. Andreas Weber, Enlivenment. Towards a Poetics of the Anthropocene (Cambridge, Massachusetts: MIT Press, 2019), p. 26.

70. Andreas Weber, *The Biology of Wonder. Aliveness, Feeling, and the Metamorphosis of Science* (Gabriola Island, BC: New Society Publishers, 2016), p. 195.

71. Karen Barad, "Nature's Queer Performativity (the authorized version)," in *Kvinder, Køn og forskning/ Women, Gender and Research* (Copenhagen, 2012), no. 1–2, pp. 25–53.

72. Donna Haraway, *Staying with the Trouble* (Durham, NC: Duke University Press, 2016), p. 30.

73. Shiner, Larry, *The Invention of Art. a Cultural History* (Chicago: University of Chicago Press, 2001), p. 3.

74. https://utne.com/mind-and-body/starhawk-principle-of-the-goddess-the-reclaiming (accessed May 2021).

75. Isabelle Stengers, *Au temps des catastrophes*, (Paris: La Découverte, 2009), p. 52 (authors' translation).
76. In *Conversation with Orland Bishop* with Charles Eisenstein https://www.youtube.com/watch?v=CqdXDIuQfdA (accessed December 2020).
77. Robin Wall Kimmerer, *Braiding Sweetgrass, Indigenous Wisdom, Scientific Knowledge, and the Teachings of Plants* (Minneapolis: Milkweed Editions, 2013), p. 142.

Thanks to our Patreon Subscribers:

Lia Lilith de Oliveira
Andrew Perry

Who have shown generosity and
comradeship in support of our publishing.

Check out the other perks you get by subscribing
to our Patreon – visit patreon.com/plutopress.
Subscriptions start from £3 a month.